25 PROJECTS

TO IMPROVE YOUR PHOTOGRAPHY

Tom Grill
and
Mark Scanlon

AMPHOTO
American Photographic Book Publishing
An Imprint of Watson-Guptill Publications
New York, New York 10036

Copyright © 1981 by Radial Press, Inc.
Photographs copyright © 1981 by Tom Grill.

First published in New York, New York, by American Photographic Book Publishing: an imprint of Watson-Guptill Publications, a division of Billboard Publications, Inc., 1515 Broadway, New York, NY 10036.

Designed by Tom Grill.

Library of Congress Cataloging in Publication Data

Grill, Tom, 1944-
 25 projects to improve your photography.

 Includes index.
 1. Photography. I. Scanlon, Mark, 1945-
II. Title.
TR146.G695 770'.28 81-10964
ISBN 0-8174-6298-8 AACR2
ISBN 0-8174-6299-6 (pbk.)

Manufactured in the United States of America

First Printing, 1981

1 2 3 4 5 6 7 8 9/86 85 84 83 82 81

CONTENTS

INTRODUCTION **9**

1. DISCOVERING LIGHT **15**
• Exposure • The meaning of lines

2. TEXTURE AND FORM **21**
• Light angle • Architectural form • Surface texture

3. LIGHT TABLES **27**
• Construction • The subject • The background
• Metering

4. NIGHT CITYSCAPES **31**
• Camera motion • When to shoot • Exposure

5. AVAILABLE LIGHT **35**
• Contrast

6. WINDOW LIGHT **41**
• Quality of light • Reflectors • Positioning camera
and subject • Metering

7. TRAVEL SEQUENCES **45**
• A systematic approach • Filters

8. PROPERTIES OF FILMS **51**
• Grain • Grain and enlargements • Camera format
• Color balance • Pushing film

9. JOURNALISTIC PORTRAIT 59
• Equipment • Lens distortion • Relating subject to background

10. COMPOSITIONAL FRAMING 65
• Functions of a frame • Strong vs. weak frames

11. BLUR MOTION 71
• Determining amount of blur • Shutter speed
• Panning • Bracketing shutter speeds

12. SEAMLESS BACKGROUNDS 77
• Neutral surfaces • Reflective backgrounds
• Lighting

13. SINGLE BACKLIGHT 83
• The setup • Arranging components • Metering

14. TRANSLUCENT SUBJECTS 89
• Backgrounds • Reflections • Metering

15. REFLECTIVE SUBJECTS 93
• Effect of reflections • Controlling reflections
• Adding definition • Camouflaging the camera

16. DOUBLE EXPOSURES 99
• Preplanning • Producing dark areas • Handling the film • Strobe effects

17. SCENICS 105
• Maximizing image sharpness • Contrast control

18. BRILLIANT SUN 113
• Metering • Bracketing • Lens flare • Diluting the sun's intensity

19. SUNSETS 119
• Recognizing photographable sunsets • Controlling the sun's intensity • Foreground detail • Enhancing color • Metering

20. INVESTIGATING A SUBJECT 125
• Exploring with a camera

21. ABSTRACT COMPOSITIONS 131
• Identifying abstract qualities • Photographing the object

22. SHADOWS 137
• Adding mystery • Emphasizing shadows • Composition

23. OUTDOOR PORTRAITS 143
• Introducing a smooth light • Reflectors • Positioning the subject

24. DISPLAYING A PRINT 151
• Mounting • Frames • Displays

25. APPLYING WHAT YOU HAVE LEARNED 157

APPENDIX 163

GLOSSARY 165

INDEX 167

In photography there is no substitute for experience. No matter how much native talent you were born with, only through repetition, practice, and self-discipline will you develop the skills that result in effective—and sometimes even outstanding—photographs. Even if you are a novice, by taking the time and making the effort to expand the limits of your photographic knowledge, you can develop a photographer's "eye" and use it to exploit the medium of photography to its fullest. Without such an effort, in all likelihood, there will be nothing in your photographs to lift them above the realm of the ordinary.

With experience you will learn to avoid the obvious and to search out the unusual. For example, this photograph of the Eiffel Tower is effective because of the use of an unusual angle. Just as important, the photograph reflects a variety of techniques that were employed to circumvent problems posed by overcast weather. Only by drawing upon a reserve of knowledge, based upon wide experience, was it possible to obtain a creditable photograph under adverse conditions.

The twenty-five projects presented on these pages are specifically designed to help you develop the skills and critical faculties on which great photographs are based. The time you spend completing these exercises will involve you in many hours of challenging photographic exercises and at the same time will help bring to fruition your full technical and creative potential as a photographer.

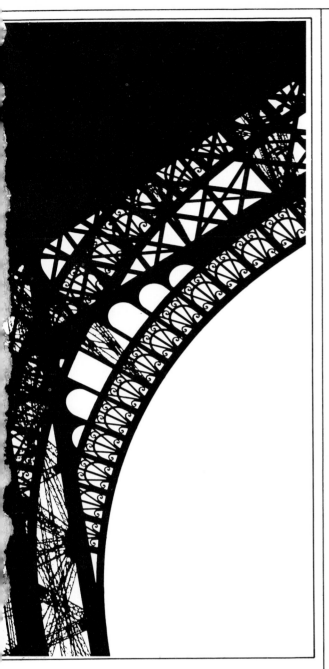

INTRODUCTION

What constitutes good or even great photography? How can *you* learn to take photographs that are exciting, creative, pleasing to look at, and a credit to your talent?

The ready availability of automatic cameras has led to the widespread misconception that expertise in photography is simple to acquire. When all you seem to need in order to take photographs is to point and shoot, it is easy to assume that by merely pointing and shooting more the quality of your photographs will inevitably improve. However, simply exposing more and more film is not alone sufficient for you to develop the thorough knowledge of all aspects of photography that makes the difference between casual snapshots and well-thought-out photographs.

Since educators have long recognized that learning occurs most efficiently and effectively when a student has clear goals in mind and a methodology to reach them, our intent in *25 Projects to Improve Your Photography* is to provide you with preconceived photographic goals backed by proven approaches, which accomplished photographers have found invaluable for refining their skills. Because expertise in photography involves discovery, we intentionally do not tell you step by step how to reach each goal. Instead, we give you guidelines and then let you experiment and apply your own imagination and creativity. In the process, you will gain an invaluable commodity: experience.

How important is experience? The oft-used analogy to driving a car applies well. The novice can perform adequately as long as nothing unusual occurs, but in the face of situations requiring fast, accurate decisions, the novice flounders or takes incorrect actions. Similarly, a novice photographer cannot handle unusual situations and may not even be aware when unusual conditions are present.

Every one of the world's most respected photographers achieved success not by random chance but by dedicating himself or herself to the pursuit of excellence. By duplicating some of their learning methods, you stand an excellent chance of also duplicating some of their successes.

The projects in this book are designed to help you gain experience in approaches to and areas of photography with which casual photographers are often totally unfamiliar. Some of the projects concentrate on improving your technical skills, while others are directed toward refining your aesthetic eye. Many projects contain some elements of both.

Although most of the projects are self-contained and do not rely for success on your having completed an earlier project, we suggest that you attack the projects more or less in the order they are presented. Particularly toward the end of the book, your ability to obtain the greatest benefit from a given

project will be enhanced by the knowledge you have gained from previous projects. Indeed, you should make an effort to incorporate techniques you have previously learned into succeeding projects. Your photographic knowledge is experiential and cumulative and only becomes ingrained if you use it frequently.

Most of all, remember that you learn photography by *doing* photography. It is not sufficient to read about a technique; you must *practice* that technique. Moreover, just as important as knowing when a particular technique is called for is knowing when conditions are such that a technique will not work. Consequently, a valuable part of the learning process involves making "mistakes," i.e., testing the capabilities of equipment and techniques until you know not only their uses but also their limitations. Toward this end, many of the projects ask you to execute procedures that will force you into making "mistakes." In the process of evaluating your photographs, you will use these "mistakes" to learn to recognize shortcomings and how to rectify them.

Darkroom Processing. True expertise in photography requires that a photographer have experience in the darkroom. Even photographers who choose to let someone else process their film and prints should be thoroughly familiar with darkroom capabilities if they ever expect to be true masters of the medium of photography.

Because of the importance of darkroom procedures, we refer to the darkroom when appropriate. However, in recognition of the possibility that you may not have access to a darkroom, we have designed the projects so that you can rely on commercial processing labs, if necessary. Nonetheless, we strongly urge that if you are at all serious about learning photography you arrange to learn about darkroom processing. Your photographs will be better for your efforts, and you will have the advantage of seeing results much more quickly than if you send your film out for processing.

Bulk film loaders. You cannot be miserly with film if you expect to make rapid progress in improving your photographs. However, there are some ways you can cut your expenses.

When you purchase film in standard cassettes, film costs mount quickly. Consider, therefore, buying a bulk film loader, which will permit you to buy film in 100-foot (30.5m) rolls and then dispense only as much as you need into special film cassettes. You will have saved the cost of the bulk loader by the time you have expended your first 100-foot roll.

An additional advantage of using a bulk loader is that you can load a cassette with only as much film as necessary to complete a particular project. You will then be able to process your results without wasting unexposed film or waiting until remaining frames have been exposed.

A drawback to using bulk film is that unless you use a custom developing lab, you will have to develop the film yourself. Fortunately, developing both black-and-white and color films requires very little equipment, does not require a formal darkroom (all you need is a light-tight room or a changing bag in which to work for the few seconds it takes to load film from a cassette into a developing tank), and is easily learned from a book. Again, the money you save in using bulk film will quickly recoup the cost of a developing tank and chemicals.

Prepaid color film. You can substantially reduce the cost of Kodachrome film if you buy film that already includes

the cost of processing. Check the advertisements in the back of *Popular Photography* and *Modern Photography* magazines for the names and current prices of companies that sell prepaid Kodachrome by mail.

Equipment. Because cameras and lenses are expensive, you may be reluctant to spend additional money for accessories, especially for accessories that seem very specialized. If you are serious about improving your photographs, you cannot avoid some expenditures. By not having on hand some basic items, you will limit your ability to derive the full benefit from these projects.

You should have on hand, in addition to your camera and a "normal" lens, the following items:

1. *A set of filters.* As a minimum you should have a red or orange filter for black-and-white photography. If you shoot a substantial amount of color film, 80A, 80B, and 85B filters will be useful for balancing colors.

2. *Tripod.* No serious photographer should be without a tripod. Avoid, however, the least expensive models. A tripod is worthless unless it is sturdy enough to support a camera rigidly.

3. *Light source and stand.* As a minimum you should have a small electronic flash unit as well as at least one incandescent photographic lamp and a stand on which to mount it. Although elaborate and expensive light systems are available, a single photo-flood lamp will be sufficient to execute any of these projects that require artificial lighting. For less than fifteen dollars you can buy a simple stand on which to mount the lamp.

4. *Umbrella reflector.* In order to help you control artificial light, a photographic umbrella is indispensible. You can use a circular umbrella or a square-type, which can be adjusted to focus the light into as narrow or broad a beam as you want. Be sure to purchase a clamp to attach the umbrella to your light stand.

5. *Cardboard reflectors.* Art supply stores sell sheets of white cardboard which are very handy for reflecting light where you want it. Buy three 32″ × 40″ (81 × 101.6 cm) sheets and cut one up into smaller sizes as you need them. For serious studio work, 4 × 8 ft. (1.2 × 2.4m) sheets mounted on a core of styrofoam are also available. Two of these sheets taped together make a mammoth reflector that stands up by itself.

Ideally, in addition to a normal lens, you will have a wide-angle lens and a telephoto lens. Limiting yourself to a single lens deprives you of the ability to capitalize on one of the most useful aspects of modern-day photography.

Camera and lens. Cameras which take film sizes smaller than 35mm suffer from image deterioration when enlarged, so cameras which take 35mm film are the smallest with which serious photographers work. Since 35mm cameras and lenses are particularly versatile and light, 35mm photography is especially popular today. Most references in this book are to 35mm cameras, but the projects can be performed with equally valid results using any camera format at all.

Most of the items of equipment listed above are available from photo supply stores, but often mail-order houses have wider selections and better prices. We suggest you write or telephone the following companies for their catalogues:

Spiratone, Inc.
135-06 Northern Blvd.
Flushing, NY 11354
(212) 886-2000

INTRODUCTION

Competitive Camera
157 West 30th Street
New York, NY 10001
(212) 868-9175

Include $.50 for the Spiratone catalogue and $2.00 for the one from Competitive Camera.

Record keeping. In most of the projects you will be asked to perform experiments and then draw conclusions from your results. To avoid later confusion, you should keep accurate records of each frame of film you shoot in the course of working on a project. Camera stores sell pads of paper on which you can record pertinent information, or you can make your own form and have copies made as you need them. At right is a sample format you might use.

These projects assume that you have a basic understanding of the fundamental concepts and procedures of photography. If you lack such an understanding, before tackling these projects you might read our book *Taking Better Pictures With Your 35mm SLR* or another book containing similar background information.

Do not be deceived by the "mundane" subjects these projects direct you to photograph. We have intentionally chosen commonplace subjects in order to emphasize that it is you, the photographer, who makes a photograph, not your subject. Indeed, these projects are carefully designed to focus your attention away from subject and onto *photography.* There is little challenge—or skill—involved in taking an interesting photograph of an already exciting subject. The true challenge and expertise lies in making an interesting photograph using a *dull* subject.

Take your time as you do these projects. One of the aims of this book is to help you learn to see the world in terms of light, rather than in terms of subject. This skill takes time to develop. By executing each project carefully, you will be ingraining in yourself a new photographic awareness. The process cannot be rushed, but the reward for your patience and diligence will be an ability to take better photographs than you ever thought possible.

FILM RECORD SHEET

Roll #_____ Film type:_____ ASA/ISO:_____

Frame	Lens	Shutter Speed	f-stop	notes
1				
2				
3				
4				
5				
6				
7				
8				
9				
10				
11				
12				
13				
14				
15				
16				
17				
18				
19				
20				
21				
22				
23				
24				
25				
26				
27				
28				
29				
30				
31				
32				
33				
34				
35				
36				

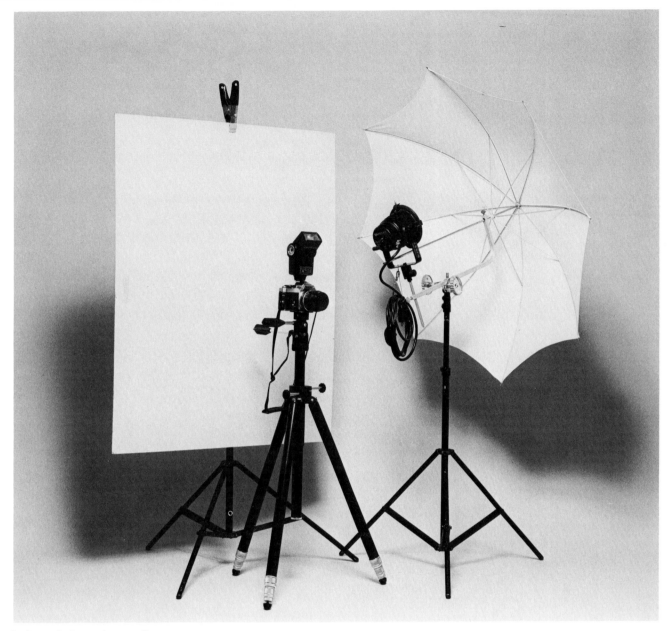

Serious photography usually requires more than just a camera and a lens, but does not require great stores of elaborate, expensive equipment. Although the items shown here may seem exotic, their use is easy to learn and they are valuable supplements to the more commonplace photographic accessories. All of the items can be purchased at relatively low cost from the sources listed in the text. By obtaining these items, you will have at your disposal the resources you need to be able to master many important photographic techniques. By employing these items routinely, when their use is appropriate, you can dramatically improve your ability to produce the best photograph possible in any situation and under any conditions.

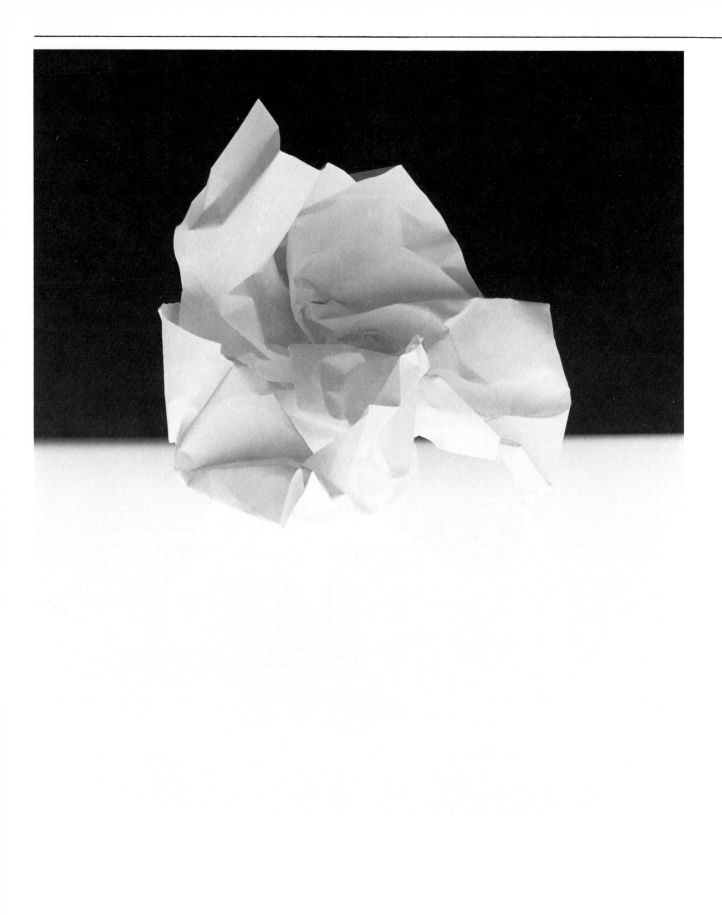

1 | DISCOVERING LIGHT

By treating even so humble an object as a sheet of paper imaginatively, you can instill a message in a photograph and sometimes even elevate it into a work of art.

The simple act of wrinkling the paper produced surfaces which immediately generate a feeling of volume. Each surface reflects, absorbs, and transmits light differently, resulting in variations in tone which define the structure and volume of the paper within the photograph.

Equally important, the lighting treatment employed does more than simply show what the crumpled ball of paper looks like. Illuminating the paper from underneath by placing it on a light table (see Project 3), allowed light to pass through the paper, thereby making the statement photographically that paper is thin and translucent. This treatment clearly illustrates a characteristic of paper that distinguishes it from other objects—a rock, for example—and as such makes effective use of the capabilities of photography. Thus, the meaning introduced by the presence of multiple surfaces in the paper was supplemented by the way the ball of paper was lit.

Despite the ever increasing popularity of photography as a means of recreation, most photographers pay little attention to the critically important idea that photography, as its name implies, is "writing with light." By developing an understanding and appreciation of the role of light in photography, you will not only improve your ability to express yourself through your photographs but at the same time you will also enhance the satisfaction you derive from taking photographs.

A piece of paper in and of itself has little or no intrinsic meaning photographically. (If you were to photograph a blank sheet of paper without including the edges of the paper within the frame, the resulting image would consist of nothing more than a blank field.) Clearly, without variations in tone resulting from the presence of a variety of light intensities, an object presents only a monotone to a camera. Therefore, unless some areas in a photograph are darker or lighter than other areas, the image is meaningless. Since variations in tone result from differences in intensities of light, a photograph really is nothing more than a collection of different light intensities. Consequently, skill in photography really boils down to the ability to control the light intensities—and hence the tones—present in a scene.

As a photographer you have at your disposal two general approaches to the control of light. You can manipulate the subject of your photograph within the light that is available. Or you can manipulate the light present in a scene by making the light brighter or dimmer, by changing its angle, or by changing the light's "quality" by using reflectors and diffusers to modify the harshness of the shadows it produces. (Of course, you can employ both approaches simultaneously, if you wish.)

To a great extent, different light intensities result from more than one surface facing the camera. Different orientations of these surfaces relative to the light source produce the variations in light intensities that add interest to photographs.

Because a blank sheet of paper consists of only one smooth surface facing the camera, the image formed says nothing visually. As soon as you introduce additional surfaces onto the paper—by folding it, wrinkling it, cutting it, tearing it, or by any other means you can think of—you simultaneously introduce areas of light and shadow and begin to make your photograph mean something to a viewer. With practice, you can learn to control your lighting fully so that it supports the message you want your photograph to convey.

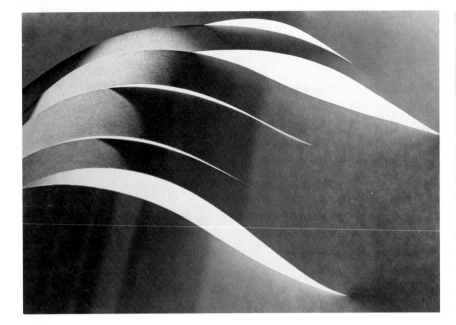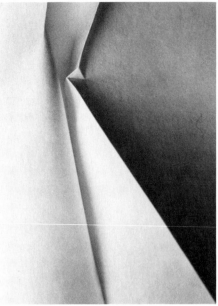

WHAT YOU NEED TO KNOW

EXPOSURE

Obviously, light must strike film in order for an image to be recorded. By using your camera to control the amount of light that reaches the film, you determine the brightness or darkness of the image formed. Light meters are designed to aid you in determining the specific combinations of lens aperture and shutter speed (otherwise known as the "exposure") that you should use for a given lighting situation to produce a film image with tones that appear normal and natural to the eye.

Because most scenes contain a variety of different tones ranging from white through grays to black, light meters are calibrated to measure an *average* of the various tones present and produce an image on film with an average (18 percent) gray tone. As long as the area of a subject being read by a light meter contains a representative range of tones, the meter will indicate exposure settings that will seem normal and natural to an observer of the final image.

A problem arises when the scene being measured with a light meter deviates substantially from being 18 percent gray on average. For example, if you were to photograph a totally white wall using the exposure setting indicated by a camera's light meter, the resulting photographic image would appear not white but gray (18 percent gray, to be exact). Likewise, if you were to photograph a totally black wall using the setting obtained from a light meter, the image on film would again be 18 percent gray.

Two methods exist for eliminating misleading meter readings. Instead of reading the entire scene, insert an 18 percent gray card (readily available from camera stores) into the scene. Then bring a hand-held light meter or a through-the-lens metered camera close enough to the card so that the meter is reading only light reflected off of the card. The meter will yield exposure settings that are correct. Alternatively, you can use what is known as an "incident light meter" which, rather than reading reflected light, directly measures the light falling on a scene and is therefore not affected by the tones actually con-

Lines in a photograph have meaning in and of themselves. In the two photographs on this page, the goal was not to illustrate the qualities of paper, but to use the paper as a means for producing interesting forms. That the forms are being generated on paper is apparent, but the fact that paper is involved is irrelevant to the meaning of the photographs.

In the photo at left, above, slits were cut in the paper with a razor blade, then the sheet was twisted into a graceful form. The lines produced by the slits were accentuated by passing a strong light through them from behind. The message results strictly from the graceful feeling of the curves as they suggest leaves falling or grass blowing.

Similarly, in the photograph at right, above, meaning flows from the presence of sharp lines implies force and tension, suggestive perhaps of a knife blade. Again, the paper is merely a vehicle for the form.

As with any abstract composition, meaning in these photographs does not derive from knowing what the subject is, but solely from the patterns present. Meaning and form are one and the same. Although recognizable, the paper serves only as a carrier for light and shadow.

tained within the scene. Both methods yield exactly the same result but the latter method eliminates the need for the gray card. (See *Appendix*.)

Measuring light that has been reflected off of a gray card can be an excellent exercise for learning to recognize when a scene deviates substantially enough from an average 18 percent gray tone for exposure compensations to be necessary. With practice you will be able to estimate by eye any needed adjustments.

THE MEANING OF LINES

Lines in a photograph can be actually physically present in the subject or can merely be formed as the result of shadows. Because lines by themselves can say something about the subject, can convey a feeling or mood, or can be used compositionally to direct attention, by being aware of lines and their meanings you can use them to support the message of a photograph.

The meanings that lines have are reminiscent of the associations they have in nature. Curved lines reflect the peace and calm of a gently rolling sea, while straight lines have the harsher feeling of unbending rigidity. Lines that converge to a point suggest motion and direction; vertical lines connote upward, thrusting movement.

In addition to suggesting feelings, lines play a role in leading the eye of a viewer from point to point within a photograph. By paying attention to where lines are located in your photographs and where the lines lead the eye, you can focus a viewer's attention where you want it.

YOUR PROJECT

Choose a sheet of white paper (or several sheets of the same paper) and, using two or three rolls of film, complete the following projects:

1. Take some photographs that reveal some of the qualities of paper—for example, flexibility, translucency, malleability, or its ability to be creased.

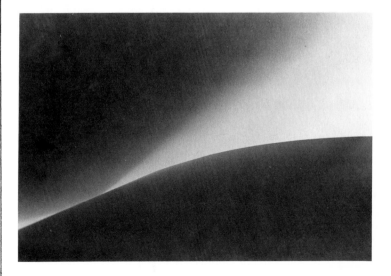

If the subject of a photograph is completely unidentifiable, the photograph becomes a total abstraction.
In order to take the two photographs at the bottom of this page, the sheet of paper was given a single twist and photographed using the setup shown in the photograph immediately below. Not only is the fact that paper was used unimportant to the meaning, an observer would probably not even be able to discern that it was paper.
As with the photographs on the previous page, the subject of these photographs is not the paper, but abstract form: in this case, a curve. Moreover, because the object being photographed (the paper) is not identifiable, the decision as to what constitutes a "correct" exposure becomes completely arbitrary. Even though the two photographs below result from exposures that differ by two *f*-stops, neither exposure is more "correct" than the other. The only difference is that one photograph has a light, airy feeling, while the other leaves a heavier, more somber impression.

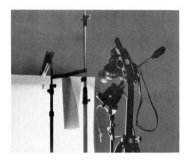

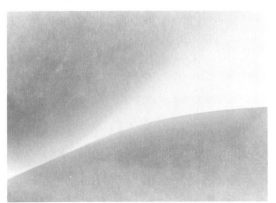

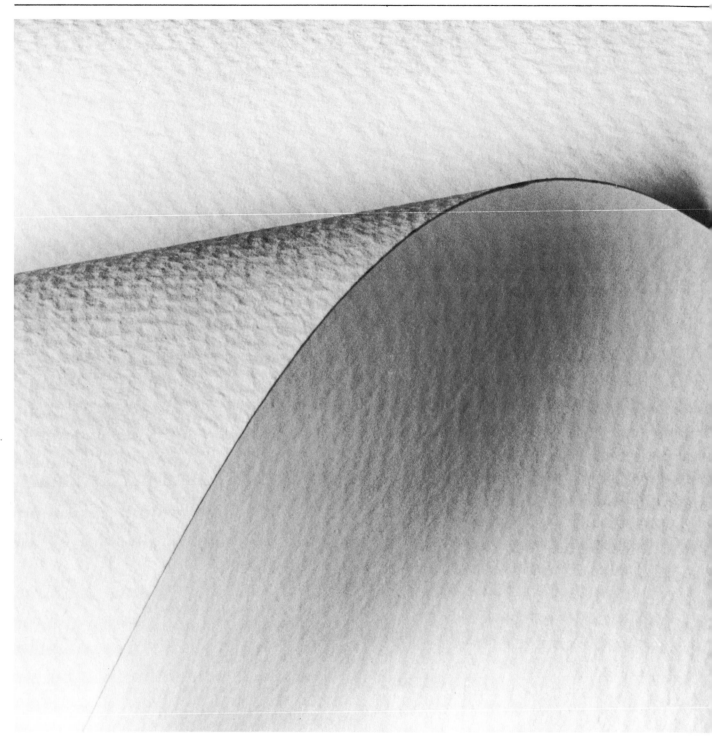

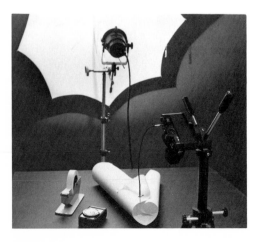

For a photograph to make a cohesive statement, the meaning conveyed by the light should complement the photograph's subject or the statement being made.

In this photograph, the goal was to reveal the qualities of *this* sheet of paper as closely as possible, almost as if the manufacturer of the paper had requested a portrait of the sheet for use in a sales brochure. Toward this end, the paper was first formed into graceful, curved lines. Next, the light source was positioned so that it would skim across the surface of the paper and thereby reveal the paper's texture. Finally, the light was bounced out of a reflective umbrella to remove some of the harshness produced by direct lighting.

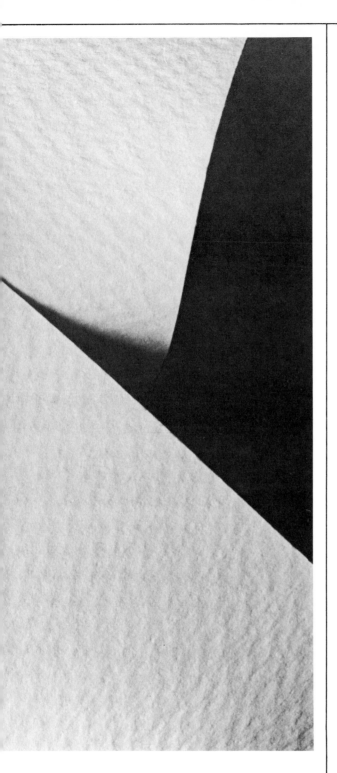

2. Use paper to create completely abstract images. Try to convey meaning through the use of line and form. Pay particular attention to the grays and blacks produced by shadows.

As you work, keep frame-by-frame notes on the meaning you are trying to convey, then evaluate your results by asking someone you know to try to identify the meaning you were attempting to capture.

As an advanced project, repeat this project after you have completed this book and compare your before-and-after results.

A SAMPLE PROJECT

In the sample project shown in the photographs on these pages we have manipulated a blank sheet of paper (and, to a lesser extent, the light source) in order to illustrate how surfaces and the way they are lit are critically important in photography. Notice, as you study the results, how different each photograph is from the others, even though the basic elements—light and paper—remain the same in each. Notice especially how light itself has feeling and how it can be used to express or support an idea.

The angle at which light strikes a three-dimensional object relative to the camera determines the extent to which the *form* of an object is apparent in a photograph.

In the photo at left, below, "flat" light striking the cube directly from the front emphasizes the two-dimensional qualities of the cube. In the right photo, moving the light source to one side and darkening the background immediately behind the cube produces differences in shading which lend the cube a decidedly three-dimensional look.

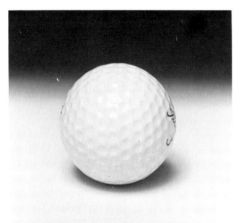 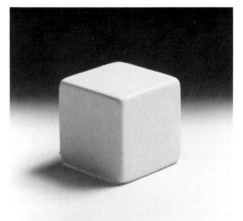

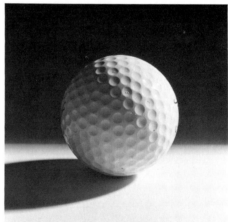

The angle at which light strikes a surface relative to the camera also determines the extent to which the *texture* of the surface is apparent in the photograph.

In the photo at left, above, flat light striking the side of the golf ball facing the camera obscures the ball's dimples. (The ball's form is slightly defined because its sperical shape causes shading to occur along the sides, top, and bottom.) In the right photo, moving the light source to the side causes the light to skim along the ball's surface and reveal textural details.

2 | TEXTURE AND FORM

Although a photograph is two dimensional, photographers frequently want to reproduce the appearance of objects that exist in three dimensions. By skillfully using light and shadow to suggest the form and texture of objects, you can create photographs that simulate the appearance of three-dimensionality.

WHAT YOU NEED TO KNOW

LIGHT ANGLE

The angle at which light strikes a surface has a direct effect on the way the form and texture of that surface appears on film. Light that originates from a point perpendicular to a surface is "flat"; the light illuminates the surface brightly but does not reveal texture. As the light angle changes from being perpendicular to being parallel to a surface, projections and crevices on the surface produce and acquire shadows that reveal the surface's texture.

Moreover, the orientation of different surfaces (or of different parts of the same, *curved* surface) relative to the light source is important. In the presence of a single light source, any two surfaces that are not parallel to each other will receive different intensities of illumination. The more directly the light strikes a surface, the brighter the surface will appear compared to surfaces on which the light strikes obliquely. Of course, surfaces on which no direct light at all falls will be darker still.

The directionality of light—the extent to which the light acts as if it were originating from a single point—will also affect the appearance of form and texture in a photograph. The greater the directionality, the greater the three-dimensional effect produced. As a result, while the light on a sunny day may be sufficiently directional to produce strong shadows and therefore clearly define the form and texture of an object, on a hazy day the entire sky acts as the light source and any distinct shadows that are formed are too diffuse to reveal texture and form.

Finally, the angle at which the camera views a surface determines whether any shadows can be seen. Obviously, unless the camera can "see" the shadows, they have no effect.

In a studio, lighting can be positioned at will and in such a way as to enhance the appearance of form and texture, but outdoors the task is not as simple. The only control you have over the sun is to wait until a time of day when the sun is positioned advantageously, or to choose your position on the ground so that the sun is at an advantageous angle relative to your camera.

Although revealing the form of an object can be an important goal in any outdoor photograph, architecture lends itself

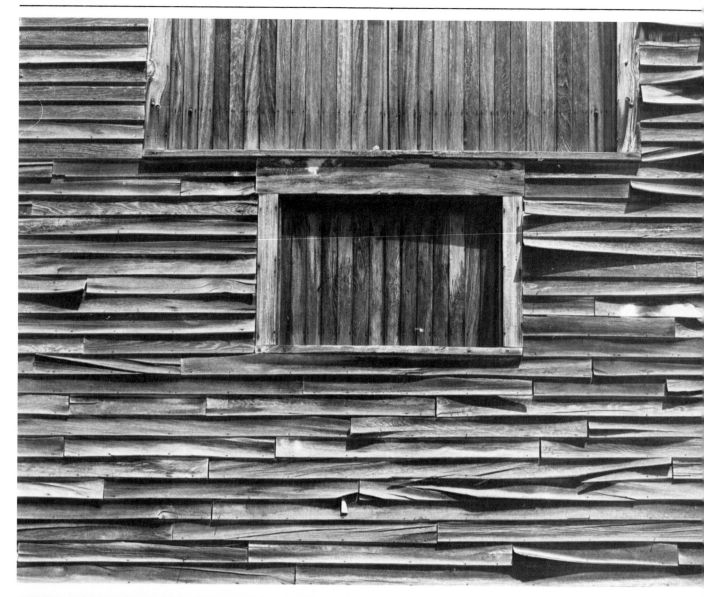

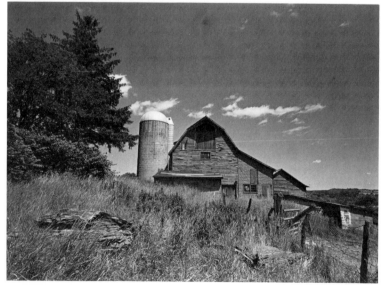

In most circumstances, the midday sun is too flat to reveal the form of a building or of other elements within a scene.

In the photograph at left, the only structural details of the building (beyond the texture of the wood) that are apparent are the overhang of the roof and the roundness of the silo. Moreover, the flat lighting deprives the trees and the foreground grass of detail that would be present if the sun were located lower in the sky. The result is that the entire scene assumes a flat feeling that robs the photograph of visual interest. The longer shadows that are formed earlier or later in the day would have improved this photograph. Light skimming across the grass would have revealed the grass's texture, and a shadow formed by the foreground rock would have added a feeling of depth to the distance between the rock and the barn that is missing in the photograph as it stands.

The appearance of texture in a photograph is strictly a matter of the angle at which light strikes a surface.

The photograph at left (which is a closeup of the barn in the photograph below) was taken at noontime on a cloudless day. Because the "grain" of the surface texture of this barn runs parallel to the ground, sunlight originating from a low angle—even if the light came from far to one side of the wall—would not have revealed the wall's texture. With the sun overhead, the shadows formed by the curling lower lips of the clapboards cause the photograph to appeal simultaneously to visual and tactile senses.

especially well to illustrating the principles involved in using sunlight to reveal form and texture. As sunlight strikes the various surfaces of a building, patterns of light and shadow develop which can help either reveal or obscure the building's structure and texture.

ARCHITECTURAL FORM

In using sunlight to reveal the form of a building, the elevation of the sun in the sky is usually critical. Almost invariably, the light from a high sun strikes all the exterior surfaces of a building identically, so each side of a building appears to be illuminated with the same light as the other sides.

Therefore, the best light for capturing the form of architectural structures generally occurs in the morning and afternoon. As noontime approaches, the light becomes less and less usable. Furthermore, the undesirable light produced by a noontime sun is more pronounced near the equator than farther north or south, where even at noon the sun is never directly overhead.

SURFACE TEXTURE

The ideal lighting for revealing surface texture is different from the best light for revealing form. In the case of texture, the sole determinant of the optimal sun position is the direction of the "grain" on the surface being photographed. As long as the light strikes a surface at an angle perpendicular to the "grain" of the surface's texture, the elevation of the sun in the sky is immaterial.

Shadows that delineate form are also useful to give a photograph a sense of scale. Flat light in a scene gives the impression that all objects in the scene exist more or less in the same plane. The same directionality that causes light to reveal form also separates the foreground of a photograph from the background. Directionality pulls the eye into the scene, and lends the photograph a feeling of depth missing from photographs taken in flat light.

The opposite condition, backlighting, in which the sun lies directly behind the object being photographed, also reduces the three-dimensionality of a scene. This is because backlighting causes objects to be thrown into silhouette, emphasizing the objects' outlines. Outlining is a perfectly acceptable and useful technique, but not when form and texture are important.

YOUR PROJECT

Photograph a building in three different lights. (Either photograph the same building at three different times, or photograph three different sides of the building in rapid succession.) Obtain at least one exposure when the light is flat, one when the light is highly directional, and one in between. In addition, make at least one exposure in a backlight to reveal the building's outline. Experiment with different lighting conditions to determine the conditions under which the form of the building is best revealed. Try to use light and shadow to give your photographs as great a feeling of depth as possible.

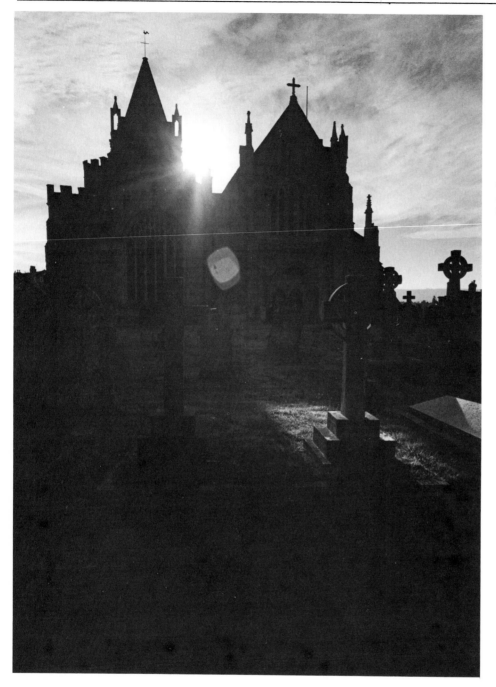

Shooting in a backlight completely obscures form and texture but clearly reveals the outline of objects.

In the photograph at left, even though some detail is evident in the face of the cathedral and in the gravestones, the most striking feature of the photograph is the way the building's outline is emphasized. Any time the sun itself is included within the frame of a photograph, an exposure that prevents the image of the sun from ''washing out'' will cause other objects to fall into silhouette.

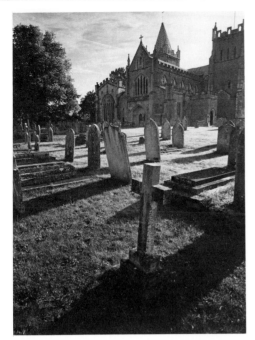

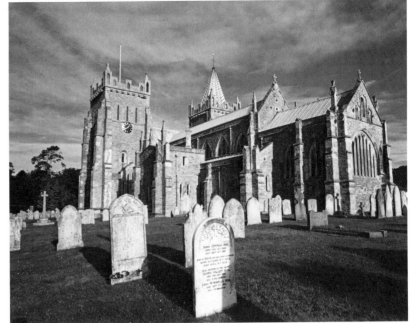

Merely changing positions slightly so that the sun was no longer in the frame caused the scene in the photograph above to take on a dramatically different feeling from the backlit photograph shown at left. Most notably, the shadows of the gravestones serve as strong compositional elements to attract the eye and draw it into the photograph. The foreground shadows create more of a feeling of depth than is present in either of the other two photographs on these two pages.

Due to the combination of light angle and camera angle in the photograph at right, above, each individual surface is either in direct sunlight or in deep shadow, depending on the surface's orientation to other surfaces. The result is a clear delineation of the building's form, and a strong feeling of three-dimensionality. Although the three photographs shown here were taken within a few minutes of each other, the photographs represent a broad range of lighting effects. Obtaining the best combination of sun angle and camera angle to reveal form or texture in a surface often requires great patience, but when achieved is worth the time and effort.

Also, take a series of photographs that reveal the texture along one or more of the building's surfaces. Experiment with different textures to determine the relationship between the roughness of texture and the best angle of light to delineate the texture.

A SAMPLE PROJECT

The cathedral used in the sample project was a good subject because its outline, form, and surface details (texture) were unusual and interesting. In addition, the cemetery contained foreground elements which could be used to illustrate the effect of shadows on the feeling of depth in a photograph.

As you study the photographs, note that they were all taken within a few moments of each other. The variations among the photographs stem primarily from the different relative positions of the building, the sun, and the camera.

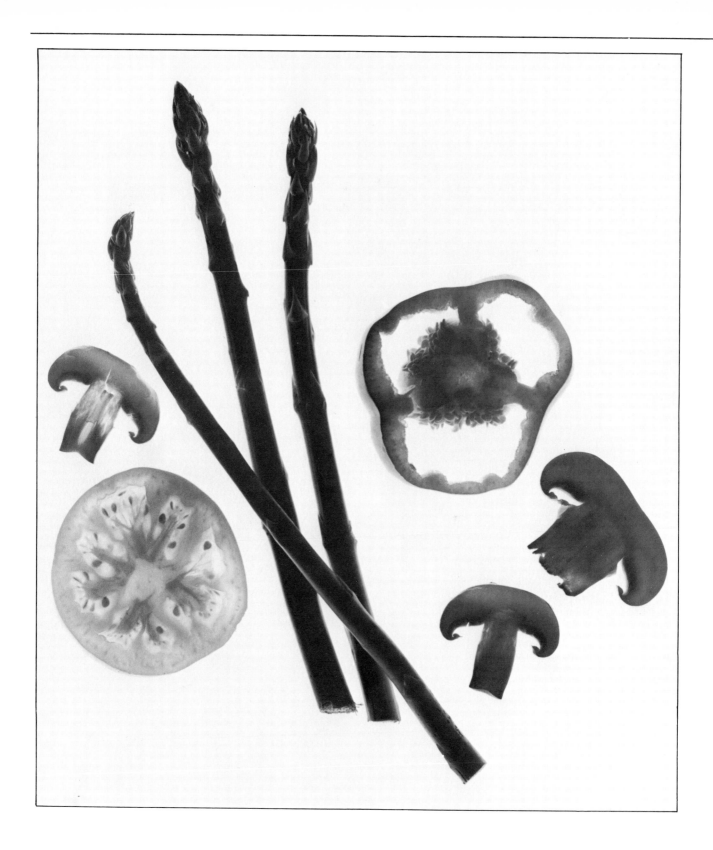

LIGHT TABLES

Pure white is a difficult color to achieve in a background. Unless the background is substantially brighter than the main subject, the camera will automatically render the background a shade of gray. To remedy this problem when photographing small objects, many photographers rely on the use of a light table.

A light table is nothing more than a sheet of translucent material through which light is shone. Light tables are easy to construct and relatively easy to work with. The light is especially useful for creating silhouettes of opaque objects and for illuminating translucent objects.

WHAT YOU NEED TO KNOW

CONSTRUCTION

To set up a light table, all you need is a sheet of translucent acrylic plastic, two sawhorses, a sheet of white cardboard, and a light source.

Translucent acrylic plastic is sold by plastic supply companies and some art supply stores. You will need a sheet at least 4' × 4' (1.2 × 1.2m), but 4' × 6' (1.2 × 1.8m) or even 4' × 8' (1.2 × 2.4m) sizes are much more versatile. Select either 1/8" (3mm) thickness or 1/4" (6mm) thickness, depending on how flexible you want the sheet to be. Flexible sheets are valuable for creating unusual effects, but thick sheets can support more weight.

Take the sheet of plastic and place it between the sawhorses. (If the sheet is long, you may need to support the sides with narrow planks.) Underneath the "table" place a 4'-wide cardboard sheet at a 45-degree angle (see illustration on next page), so that when you shine a lamp onto the cardboard, the light will be reflected up onto the plastic. Turn on the lamp and check to be certain that no direct light from the lamp strikes the surface of the plastic.

THE SUBJECT

Place the object you want to photograph on top of the table. If the item is translucent, some of the light from the table will pass through, revealing the object's structure. If the object is opaque, it will fall into silhouette.

If you want to illuminate the top of the object on the light table, you can suspend a sheet of white cardboard over the object. Light from the table will be reflected back onto the object's surface.

Beautiful effects are possible with a light table.
Because the light table passes light through some of the objects in this photograph, revealing their internal structure, these slices of vegetables form interesting patterns that would have looked entirely different had the vegetables been laid on a sheet of white paper. In the thicker objects, the light flow is obstructed so that only their shapes are apparent.

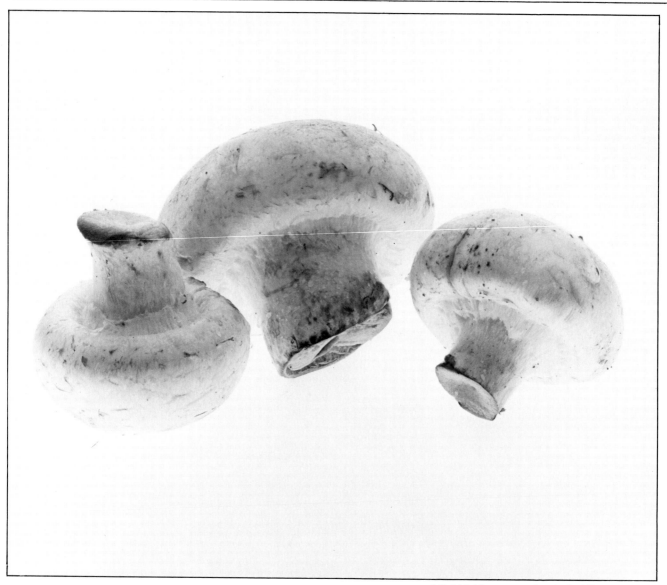

Translucent acrylic

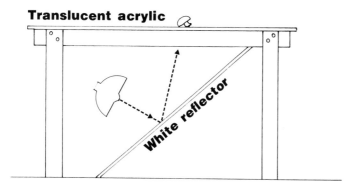

A light table uses a sheet of white cardboard to reflect a smooth light onto the bottom of a sheet of translucent acrylic plastic (left). The light passing through the plastic illuminates objects placed on the light table from below, and causes the background behind the objects to appear perfectly white.

The three mushrooms shown above were placed on a light table and then an additional sheet of white cardboard was placed overhead to bounce light onto the top surfaces of the mushrooms. Without the extra reflector, the top surfaces of the mushrooms would have appeared black.

When an object is photographed completely surrounded by the surface of a light table, the object appears to be suspended unnaturally. By including a "horizon" line formed by the back edge of the light table, you inject a frame of reference that makes an object appear less unusual. When you are especially interested in emphasizing the forms or outlines of objects, the frame of reference is not necessary. You can include it, however, if the appearance of objects being suspended in air disturbs you.

BACKGROUND

Sometimes, if your sheet of acrylic is too small or your angle of view is too low, the far edge of the acrylic sheet will appear in the frame. You can usually solve the problem simply by placing a piece of velveteen or a sheet of black paper behind the light table as a background. With color film, the background could be any color that complements the scene.

METERING

Take light readings using an incident meter (if you do not have an incident meter, see the *Appendix*). You must be careful to take your reading with the light-collection window of your meter lying at the exact center of your subject. If you hold the meter too close to the camera or too far away, the reading will be faulty. Point the meter directly at the camera while you are taking the reading.

When you take the photograph, over- and underexpose by at least one-half *f*-stop on either side of the indicated exposure. Often, a darker exposure than the one indicated by the meter will look best.

YOUR PROJECT

Construct a light table and use it to photograph some common objects. Select several objects that are opaque and others that are translucent. Also, try slicing a few objects thin enough to pass light.

A SAMPLE PROJECT

We elected to use fruit and vegetables for this project, but almost any small object will work, especially if it contains interesting shapes or patterns.

Notice that in order to produce a three-dimensional effect, you need to reflect some light onto the top of an object from above. Without the overhead light, the three-dimensional form of the objects was lost and their two-dimensional shape was emphasized.

Do not overlook the effects of a light table on color. Especially in objects that have been cut into thin sections, colors on a light table often appear unusually vibrant.

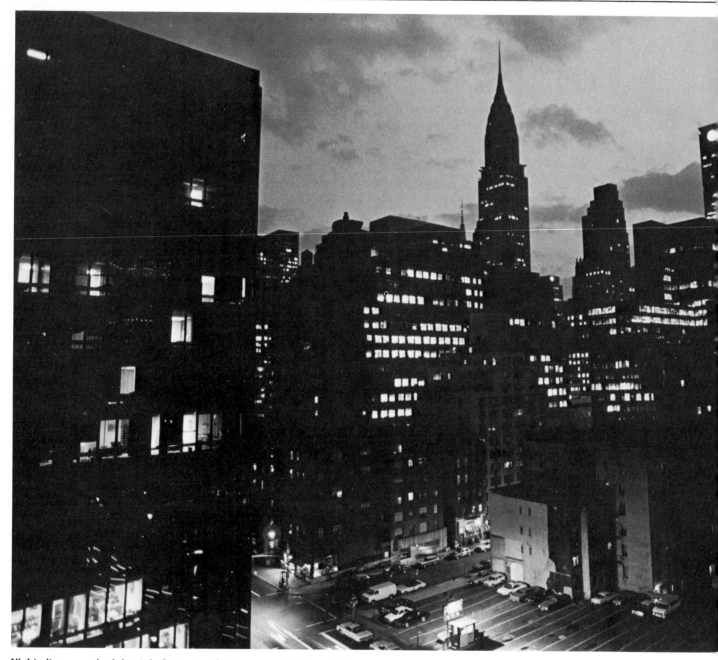

Night cityscapes look best during the brief interval when a balance is reached between the brightness of the evening sky and the brightness of office lights. With black-and-white film, night cityscapes are usually most interesting when clouds are present. Clouds are also appealing in color photographs. The presence of clouds, when using color film, is not as critical because even cloudless skies retain a warm, reddish or golden glow long after sunset.

One advantage of taking cityscapes at night instead of during the day is that the major tourist attractions of a city, e.g., Big Ben in London, the Eiffel Tower in Paris, the Acropolis in Athens, are usually well illuminated and stand out clearly from less important surrounding buildings.

5 | AVAILABLE LIGHT

In many circumstances the effects produced by available light—light that is already present in an indoor scene due to the presence of sunlight or artificial lights—cannot be improved upon by adding supplementary photographic lights. Sometimes additional lighting would distract from or disrupt a subject (for example, when taking candid photographs of a child). And at other times such lighting is physically impossible to employ (for example, in restaurants, backstage, or in a sports stadium).

Almost by definition, available light is relatively weak, so usually some compromises are necessary between three competing needs: a shutter speed sufficiently fast to stop action, a lens opening small enough to provide an adequate depth of field, and a film with a grain structure fine enough to preserve an adequate amount of detail in the subject. Usually the compromise takes the form of the need to use fast films despite their relatively large grain structure. Compromises are also sometimes necessary in shutter speed and lens opening. Despite the frequent need for compromises, when carefully employed, available light can produce some outstanding results.

WHAT YOU NEED TO KNOW

CONTRAST

The term "contrast" refers to the range of tones from the lightest to the darkest in a photograph. In a black-and-white photograph, the tones are all shades of gray; in a color photograph, in addition to tonal differences between grays are the tonal differences produced by different colors. (For simplicity we will limit the present discussion to black-and-white contrast, but similar concepts also apply to color contrasts.)

The degree of contrast in a scene depends upon the relative similarities of adjacent tones (shades of gray). If two areas of very similar tones adjoin, contrast between the tones is low. If adjoining tones vary widely, contrast is high. In addition, the term can be applied to the entire range of tones in a scene. A scene with a narrow overall range of tones is described as containing low contrast, while a scene with a wide range of tones is described as being "contrasty."

Exposure Latitude. The specific range of tones that a film can "hold" is referred to as the film's "exposure latitude." (For black-and-white film, the range is approximately five *f*-stops. For color film, approximately three *f*-stops.) When a film's exposure latitude is narrower than the range of contrasts in the scene being photographed, the film cannot hold detail in shadow areas or highlight areas (or both, depending on exposure).

Because the human eye is sensitive to a wider range of light intensities than is film, you cannot rely on your eye alone to evaluate accurately the range of tones in a scene. Instead, you must use a light meter to determine the intensities of the tonal extremes, and then adjust the tones (usually by throwing light into the shadowed areas) until they fall within the ability of the film to record them. The technique is to take a reading with a light meter (either a hand-held meter or the meter built into a through-the-lens metered camera) of the *darkest* area in which you want detail to be retained, and then a reading of the *lightest* area in which you want detail to be retained. As long as the *f*-stop readings fall within the exposure latitude of the film, detail will be retained in both extremes simultaneously.

Contrast and Available Light. In available light situations two different applications of contrast are important. On the one hand, contrast within your subject should be sufficient to delineate your subject's features. When contrast within your subject is low (less than two *f*-stops with black-and-white film, less than one *f*-stop with color), definition is lost because shadows and highlights are of almost identical intensity. When contrast is too high, stark shadows appear. On the other hand, contrast *between your subject and the background* should be sufficiently high (at least two *f*-stops with black and white, one *f*-stop with color) to insure that your subject and the background do not blend together.

Controlling Contrast. Three main factors control contrast in available light situations: the size (broadness of beam) of the light source; where you position your subject relative to the light source and the background; and the presence or absence of reflective surfaces.

The broader the diameter of the beam of light produced by a light source, the lower the contrast it produces. Thus, a fluorescent tube generates lower contrast than an incandescent bulb, and light entering a room through a window generates lower contrast than does light from a candle.

The angle at which light strikes the subject relative to the camera does not affect the actual quality of the light, but does affect the contrast as recorded by the camera. For example, if the light falling directly on a subject's face originates from behind the camera, little contrast will be apparent in the face because no noticeable shadows will be produced. If the light is shifted so that it originates at right angles to the subject, contrast in the subject's face will be high because one side of the face will be brightly lit while the other side will fall into almost total darkness.

The presence of reflective surfaces can decrease contrast if they throw light into dark areas of a subject. The larger the surface and the closer it is to the subject, the greater the decrease in contrast. The reflective surface can be an object normally present in the environment (a wall, for example) or can be provided for the occasion (a sheet of white cardboard, perhaps).

If you are to become proficient at photographing in available light, you must train yourself to evaluate the contrast in a scene and then make whatever adjustments are necessary to insure that areas of interest receive sufficient contrast to be clearly delineated, but not so much contrast that important detail is lost in highlights or shadows.

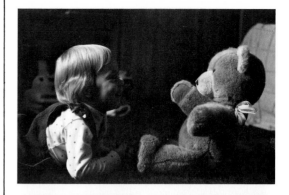

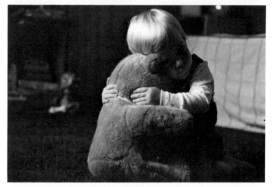

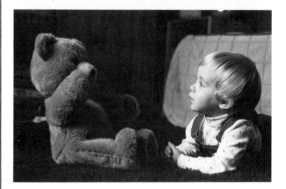

By virtue of two small changes—a slight shift in the position of the camera as well as the inclusion of fill light bounced into the scene by a sheet of white cardboard—the larger photograph at right becomes significantly improved in comparison to the other photographs on this page. The position shift causes the child's head to be defined sharply against the dark background, while the reflected light brings out the detail in areas that previously had been lost in darkness. With the addition of fill light, the tonal range of the child's entire head falls within the ability of the film to hold an image.

In the sequence of photos at left, the importance of position is readily apparent. In the top photo, because of the child's position relative to the light source, the contrast between the back of the child's head and her face is too great for the film to hold detail in both. Since the camera automatically exposed for the highlights, the child's hair is clearly defined, but not her features.

One obvious remedy was to switch the position of the child and the bear so that the light would fall directly on the child's face. However, the shadow of the bear across the child's face produced another area of low contrast. Even though to the photographer's eye the child's features could be seen clearly, the contrast nonetheless exceeded the film's exposure latitude and so her features again lacked detail.

In the lowest photo, because the child is effectively positioned to take advantage of the light and because all unwanted shadows have been eliminated, her face is clearly illuminated and the area lacking detail is now confined to a relatively unimportant section at the back of her head. A significant shortcoming still exists, however: the comparatively low contrast between the child's head and the bedcover in the background.

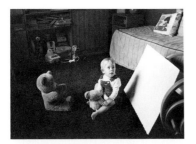

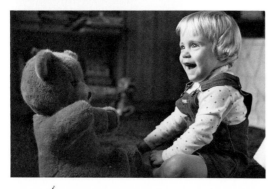

YOUR PROJECT

Perform a test that will illustrate the interrelationships between available light, contrast, and film exposure latitude as follows:

In an indoor setting, photograph a person engaged in an activity, at first using only available light. Take a wide variety of exposures, including some in which you know the contrast will be poor—either too low to delineate facial features or so high as to cause loss of detail in highlights and shadows. Vary the subject's position relative to the light and the camera. Next, add reflector fill and repeat the entire process. Take exposures with the reflector at different distances from the subject. Try to develop an eye for the appearance of reflected light.

For each exposure, take meter readings of the highlight and shadow area. When your prints have been prepared, relate the meter readings you obtained and the exposure settings you used to the amount of contrast and detail evident in the final prints.

A SAMPLE PROJECT

The photographs in this sample project were not candid shots but were arranged specifically to illustrate some of the problems that must be addressed in a typical available-light situation.

Even though the window light used for these photographs at first seemed to be strong enough to permit using the rated ASA speed of the film, the young age and restlessness of the subject required a special accommodation. With an older subject, 1/125 sec. at f/2.0 would have provided sufficient motion-stopping power and an adequate depth of field. However, children dart about so quickly that opening the lens up as wide as it could go would have required rapid focusing reflexes and extreme focusing accuracy. As a result, the film was pushed to provide an additional f-stop and hence a more forgiving depth of field.

Study the photographs at left carefully in terms of contrasts. A quick scan reveals that fairly minor shifts in position result in significant changes in contrast, and that where contrast is too high, detail is lost (especially in shadow areas). Notice also how the contrast between the child's head and the background varies from photograph to photograph. In addition, pay attention to the effect of adding a reflector on the contrast between the side of the child facing the light source and the opposite side.

Bear in mind that although in these photographs areas where detail is lost are readily apparent, at the time of the shooting there was sufficient light present for the photographer's eye to perceive detail even where shadows existed. With practice you can learn to estimate when contrast is so high in a scene that loss of detail is a potential problem. The only truly reliable method for evaluating borderline situations is through the use of a light meter.

In the above photograph, a reflector is clearly needed because the dark rug does not throw nearly enough light onto the child's face. Moreover, so little contrast exists between the rug and the toy car with which she is playing that the toy is almost unidentifiable. The challenge is to keep the reflector out of the frame while positioning it so that it throws light where required.

The solution to the problem of how to add a reflector inconspicuously under the child's face is to camouflage the reflector as an appropriate prop. The white pages of a coloring book act as an effective reflector and seem perfectly natural positioned as they are below the child's face. A second reflector located out of camera range contributes additional fill to the side of her head away from the window.

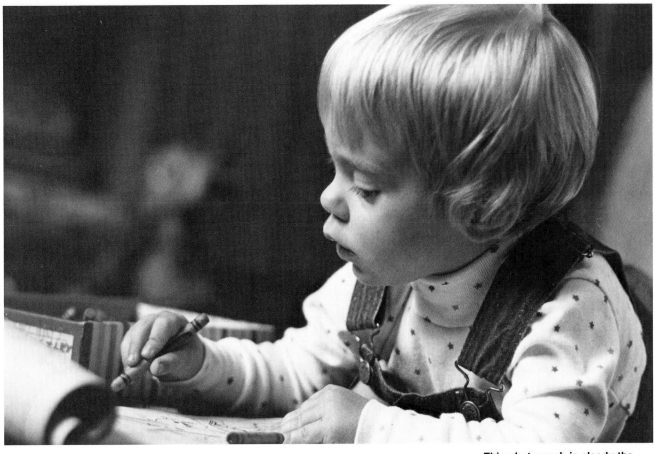

This photograph is clearly the best of the entire sample project. Aside from the convincing expression on the child's face and her obvious concentration on a very childlike activity, contrast in this photograph is nearly perfect. Notice how the tonal range across the entire photograph utilizes almost the entire exposure latitude of the film with little detail being lost in highlights or shadows. Notice also that even with the extra *f*-stop achieved by using fast film, only the child's nose and lips are held in sharp focus. Without the extra *f*-stop, the photo might have been too "soft."

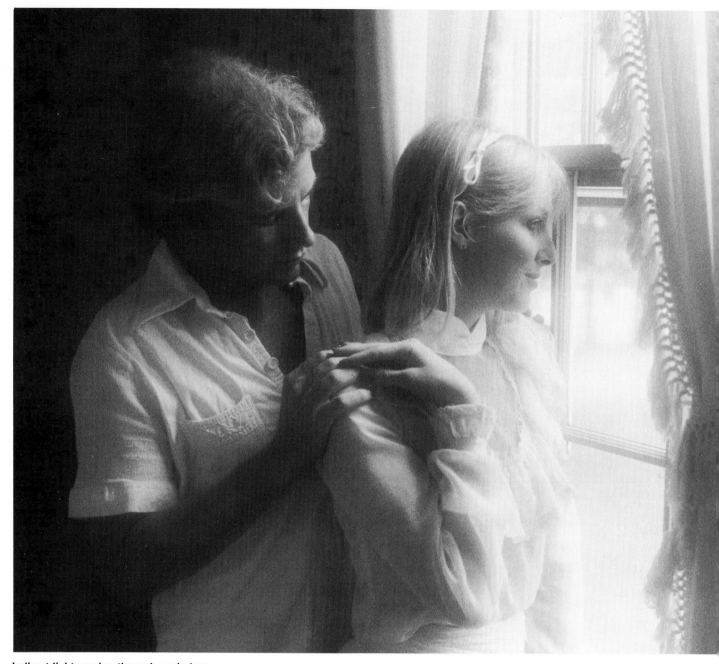

Indirect light coming through a window
produces a gentle transition from highlight
tones to shadow tones. This "softness" is
further enhanced when some of the
window light is reflected onto the side of
the subjects facing away from the window.
In the above photograph, the range of light
intensities in the scene is almost perfect:
the subjects' faces are properly exposed,
but detail is still present in the scene
outside the window as well as in the
background walls of the room.

WINDOW LIGHT

Painters have always preferred to work in the indirect light entering a room through a north window. They prefer such a light because it is "soft" and flattering and its *quality*—the way it makes things look—does not change as the sun moves across the sky. In a soft window light, highlights merge gradually into shadow, and the overall contrast range of a scene—the difference in intensity between the brightness of the highlights and the darkness of the shadows—is narrower than in a "hard" light.

Photographers like a north window light for mostly the same reasons. In particular, soft window light has special appeal for taking informal portraits. In many indoor situations the light from a flash unit would produce a portrait with a stark feel to it. Simply by moving the subject into window light, a much more flattering portrait will result. Furthermore, the natural setting of a window makes subjects feel more at ease than does a flash.

WHAT YOU NEED TO KNOW

HARD LIGHT VS. SOFT

Anytime there is a sharp line of demarcation between shadows and highlights, the light is said to be hard. If you place your subject in direct sunlight when using window light, you can be certain that the light will be hard. Otherwise, window light will be soft.

Although north light (south light in the southern hemisphere) is ideal, a window need not necessarily be facing north for the light to be soft, as long as the light is not direct sunlight. If the sky is overcast or the sun is at the proper angle, even a window with a southern exposure produces light soft enough to use. In addition, you can soften direct sunlight merely by covering the window with a sheer, white curtain.

REFLECTORS

Unless a room is very small and has light-colored walls, you will need to use a reflector to throw light onto the side of your subject that is away from the window. Any large, white surface will work. You can use one of the flat-folding reflectors sold in camera stores, or simply prop a large sheet of white cardboard on a chair.

Usually, the closer you bring the reflector to your subject without having the reflector appear in the frame, the better. At the same time, you must place the reflector where it will receive the most light.

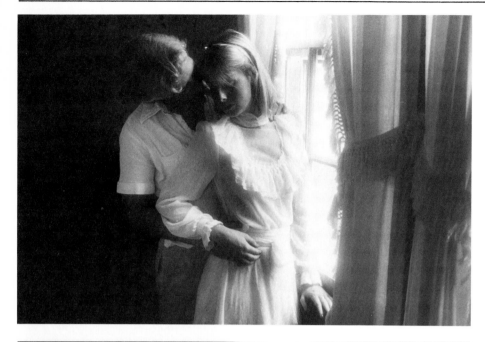

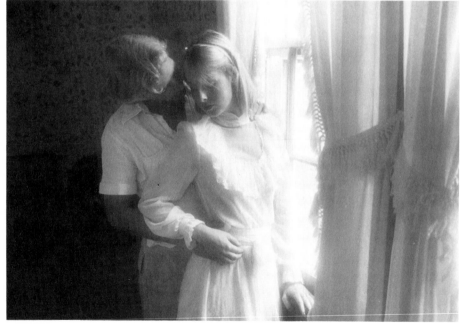

As long as your subjects are looking out the window, the exact location of the reflector is usually not critical. If you have your subjects facing inward, however, you must make sure that the reflector brings the intensity of the light on their faces near enough to the intensity of the window light to prevent the window from appearing overexposed.

In these photographs, the amount of light falling on the woman's face is sufficient, but the photograph could have been improved by bringing the reflector closer to her face. However, in the upper photograph the exposure reading was taken not from the front of the woman's face but on her cheek. As a result, the photograph is underexposed. In the lower photograph, taking the reading off the front of her face produced a better exposure.

Sometimes, in order to move the reflector as close to your subjects as you want to, you will be forced to move closer yourself, or switch to a longer lens so that the reflector does not appear in the frame.

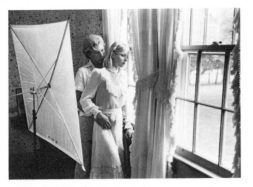

Above is a photograph of the setup used to take the two preceding photographs. The reflector shown is manufactured specifically for photography, but a large sheet of white cardboard would have worked equally as well.
Notice that the reflector is placed to one side of the couple so that they block a minimum amount of light. In this particular situation, light from an adjacent window supplemented the light coming through the window beside which the couple was standing.

POSITIONING CAMERA AND SUBJECT

Place your subject slightly off to one side of the window and facing out. Position yourself off on the other side of the window, so you are looking almost parallel to the wall the window is in and can see your subject's face. Avoid shooting directly into the window or the scene will be backlit and your problems will be increased.

METERING

Because window light is soft and as long as your reflector is close enough to your subject, the reading your meter indicates should be accurate. Be sure to take the reading off your subject's face.

YOUR PROJECT

Photograph someone in window light, with both black-and-white film and with color. Take some shots in a hard light and some in soft light. In each case, expose some frames without a reflector. Then shoot additional frames with a reflector at various distances from your subject. In the soft light, take some frames with the subject facing the window and some facing inside.

Evaluate your results in terms of exposure accuracy, softness of light, and contrast control (i.e., determine how close to your subject the reflector had to be to preserve shadow detail). Compare the contrast differences between black-and-white film and color film.

A SAMPLE PROJECT

The gentle, even delicate feeling created by window light's softness is particularly appropriate for setting a romantic or loving mood in a photograph. The photographs here are of a couple who are genuinely fond of each other.

Because window light forces them to gaze out the window, they are much more likely to strike relaxed, natural-looking poses. Imagine how different these photographs would have looked had they been taken with a flash.

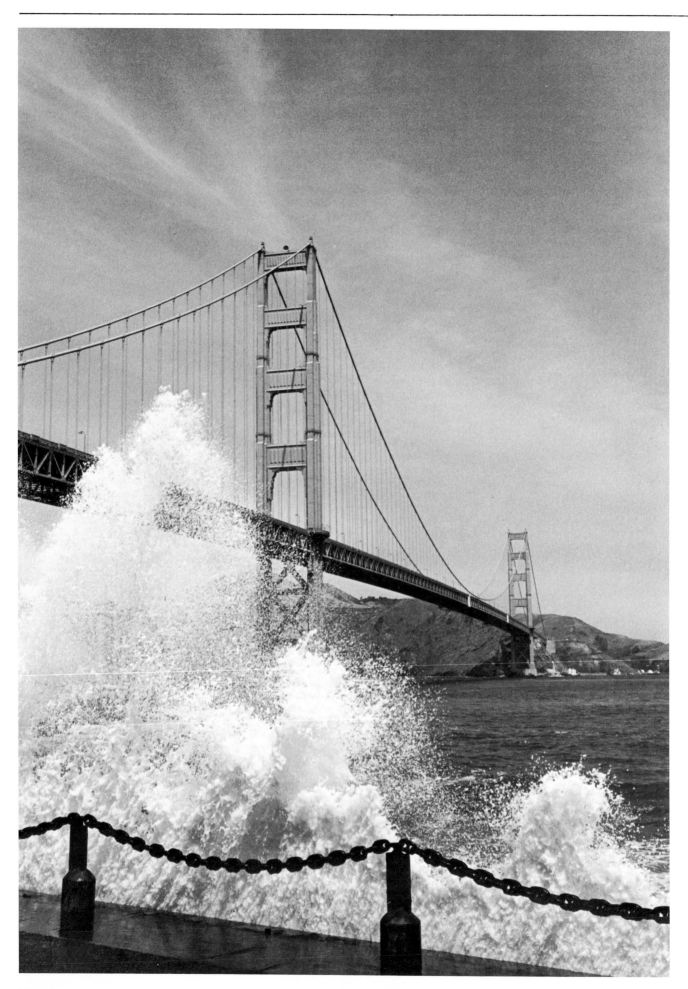

7 | TRAVEL SEQUENCES

Rarely is photography engaged in with more enthusiasm and by more people than when they are traveling. Yet a fundamental weakness of many travel photographs is that they represent little more than random collections of isolated images, many of which contain little inherent interest. Most travel photographs seem to say, "This item exists," or "I was there," but little else.

Photography has the potential to be more than simply a means for cataloguing the itinerary of a trip. Indeed, part of the fun of travel photography is the opportunity it gives you to develop a depth of understanding and appreciation for the areas you visit. The process of taking good travel photographs entails adopting a systematic approach to a subject that can add immeasurably to the pleasure you derive from your travels and from your photographs.

WHAT YOU NEED TO KNOW

A SYSTEMATIC APPROACH

A travel photograph taken hastily and without forethought stands a better-than-average chance of being dull. Conversely, a photograph that has been carefully thought out is much more likely to be interesting and present a cohesive statement about the subject.

Advance planning implies the need for a systematic approach to travel photography. In the system described here, the underlying goal is to recreate the experience of exploring the things that characterize a particular place and make it interesting or special.

The most productive approach you can take is to operate under the assumption that someone completely unfamiliar with the location and objects you are photographing will be viewing your results. If that person can obtain a clear and comprehensive idea of what the site looks like and why you considered it worth photographing, then you can assume that you have produced successful travel shots.

Three types of travel photographs. To approach a travel subject systematically, think in terms of three types of photographs: the overview, the intermediate view, and the detail shot.

The purpose of the overview is to establish the setting in which the subject is placed. Too often, travel photographs are taken from a vantage point so close to the subject that even determining whether the setting is urban or rural is impossible. Moreover, the overview can often indicate the scale of the object you are photographing.

The careful selection and placement of foreground details can add immensely to a travel photograph.
Compare these two photographs of the Golden Gate Bridge. The crashing wave in the foreground at left adds a distinct feeling of excitement and at the same time obscures the unattractive blockhouse. In addition, careful cropping of the final print eliminates a distracting curb from the foreground of the scene. Above is a sterile depiction of how the bridge looks. At left is a dynamic representation of the role the bridge serves in spanning a body of water.

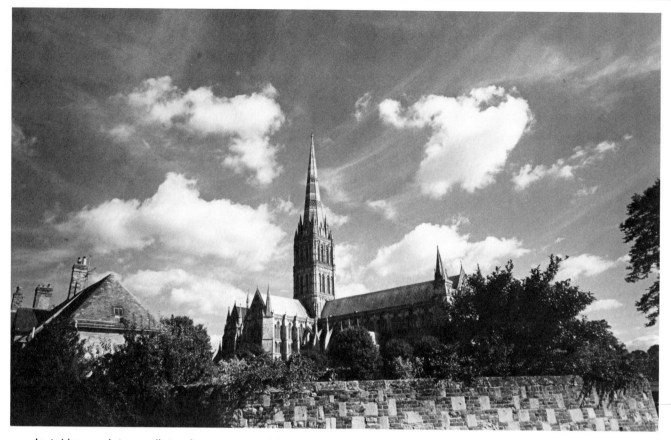

In taking an intermediate view, your goal is to reveal the gross structure or design. By photographing from a point relatively near your subject, the materials it was made from often become apparent. At this distance the angle of view in your photograph is likely to be similar to that with which the "typical tourist" views the subject.

In the detail shot, you attempt to illustrate fine points of an object that might elude the casual observer, but which characterize the particular object you are photographing. Designs carved in marble, details of construction, interesting figurines—anything that separates this object from other similar objects can be worthy of close-up detail shots.

Preparation. Since time is usually at a premium when you are traveling, you can increase your efficiency and productivity through careful preparation.

When you first arrive at a location, purchase a good tourist map of the area. Use the map to identify the major tourist sites, then analyze the map to determine when each site will be in the best position to receive light from the sun. As a rule, the best time to photograph a popular tourist attraction is in the early morning before the sunlight has become harsh and before other tourists have arrived.

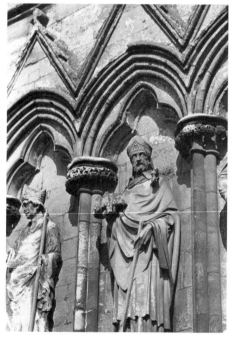

You can also glean some valuable information from postcards, travel magazines, and tourist brochures of the area. Do not try to copy the work of others, but try to determine which angles and vantage points give interesting views of the various attractions. By knowing in advance the approximate locations from which you will want to shoot, you can minimize the time you spend wandering about searching for interesting viewpoints.

Adding interest to your travel photographs. You can avoid the dullness characteristic of many travel photographs if you consistently make a conscientious effort to intro-

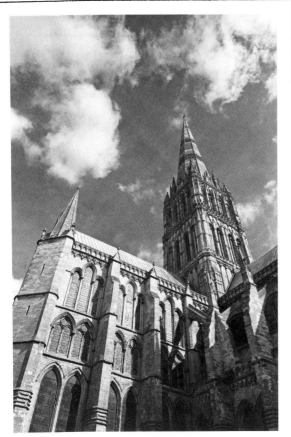

An effective travel sequence tells an informative story. Collectively, these three photographs visually explain the setting, structure, and fine details of Salisbury Cathedral in England.

From the photograph above, left, we know that the cathedral is not especially large and is located in a rural setting.

From the photograph directly above, we know that the cathedral is constructed of stones and we can study the intricacy of the building's construction.

From the photograph at left, below, we know that the cathedral's design includes typical medieval statuary. We can also discern important details of the building's fine structure.

Alone, the photograph directly above, which is similar to a typical "tourist shot" of such a structure, would tell only a limited part of this cathedral's story. Combined with the other photographs, the story is more nearly complete.

duce something unique into your photographs. Often, merely watching for an interesting or revealing foreground detail to include can improve a photograph. In addition, by the imaginative use of foreground details you often can hide other objects present in a scene which would detract from your photo.

FILTERS

Your response to a scene is more subjective than your film's, and the excitement you are feeling when you press the shutter may not appear in your photograph. One way to introduce some of that lost excitement is to shoot in the dramatic lighting that occurs at sunset or sunrise. Another way, which is sometimes effective, is to add an appropriate filter to your lens.

With black-and-white film, the most common reason to use a filter is to produce a dramatic sky. A red or orange filter will darken a blue sky and consequently increase the contrast between the sky and any clouds that are present. The result is a feeling of drama that would have been absent without the filter. Anytime clouds are present in an otherwise clear sky, you should at least *consider* using a filter.

With color film, a filter has the effect of introducing an underlying monotone of color across the image. Compositionally, the monotone gives all the colors present in the photograph a common tint so that they all have a compatible component. They harmonize with each other. The primary effect of the filter, however, is to add a feeling of excitement.

Be aware that anytime you add a colored filter to a lens, whether your film is black and white or color, exposure will be affected. Unless your lens has a through-the-lens light meter, which will automatically compensate for the effect of the filter, you must make the adjustment manually by opening the lens one *f*-stop for a filter factor of 2, two *f*-stops for a filter factor of 4, and three *f*-stops for a filter factor of 8. (Filter factors are usually engraved on the filter's mounting ring.)

YOUR PROJECT

Select a travel-type subject—a monument, a statue, a church, an important building—to photograph. (You can either execute this project while you are on an actual trip, or you can use an appropriate object in your immediate vicinity—a city hall, perhaps.) If possible, select a subject that you have previously photographed.

Using the strategy described above, produce three good black-and-white photographs of your subject: an overview, an intermediate view, and a close-up detail shot. If you own filters, take an additional three shots using a red or orange filter to compare the effect of using the filters on the appearance of the sky.

Repeat the procedure using color film, both with and without a color filter, if you have one.

For all photographs, shoot only in a dramatic light (such as in the morning or afternoon) and take whatever steps are necessary to be sure that no tourists appear in your photographs. Make a point of incorporating pertinent foreground details to add interest to your photographs and, where necessary, to obscure any distracting elements which might be present.

Evaluate your photographs in terms of how thoroughly they reveal the setting, structure, and fine details of your sub-

ject. Allow a friend to glance for no longer than one second at each of your photographs. If you have captured your subject graphically, your friend will be able to identify the subject immediately. If, after studying your photographs for a few minutes, he or she can accurately discuss the subject of your photograph in terms of its size, location, structure, and design, you will know that your endeavors have produced a collection of travel photographs far superior to those the vast majority of tourists are taking.

A SAMPLE PROJECT

The most difficult aspect of taking travel shots in this project may be eliminating people. In these photographs, people were obscured by shooting from angles that caused the people to be obscured behind walls.

In some photographs, including people is desirable if they are local residents who add "color" to the photograph. What you are trying to avoid is including camera-laden tourists.

The imaginative use of foreground details and color filters can add interest and even drama to typical travel subjects. Because Big Ben has been photographed by millions of tourists, obtaining a novel photograph presents a challenge. Selecting a viewpoint that includes a nearby lion as a strong compositional element helps in the lower photograph, but the dull, overcast sky detracts from the overall impression the photograph makes.

In the upper photograph, a magenta filter adds visual interest to the photograph without distracting attention from the clock tower. Other improvements in this photograph are the better angle from which the photograph was taken and the intentional inclusion of a double-decker bus to further characterize Big Ben's location.

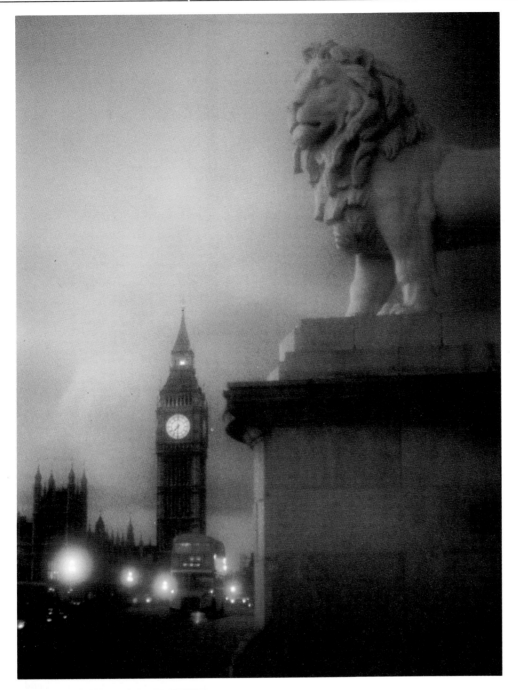

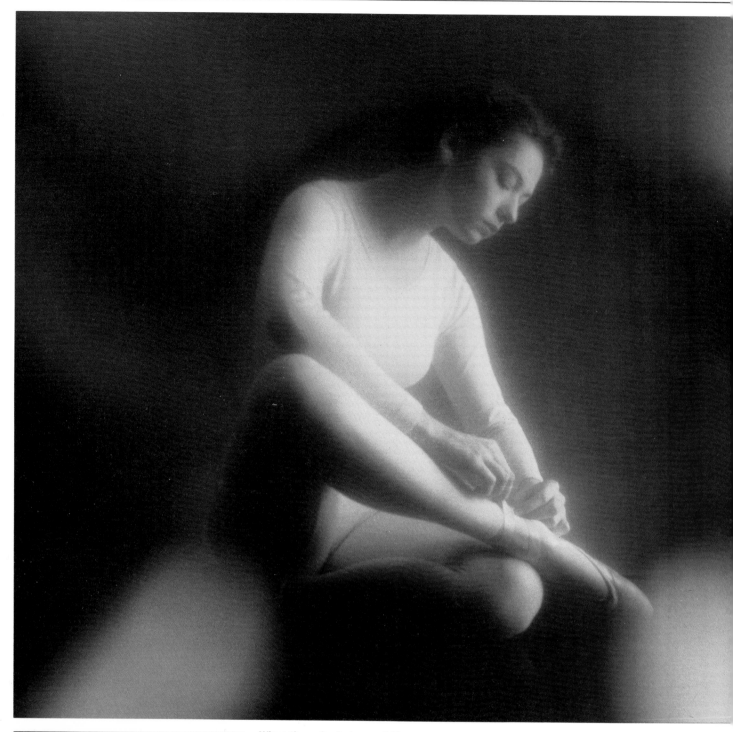

When the color balance of film does not match the color balance of the light present in a scene, a color shift results. When the shift supports the mood of a photograph, however, the effect is not distracting but complementary.
Using daylight film with a tungsten light source produced a much warmer feeling in the above photograph than occurred when the film was properly matched to a tungsten light source (left).

8 | PROPERTIES OF FILMS

To novices, the choice of a film seems arbitrary. More often than not they will see no reason to use anything other than a fast film which will permit the use of as rapid a shutter speed as possible.

As photographers develop experience, they begin to recognize that technical reasons exist for selecting one film over another. They learn, among other things, that detail in a photograph can be preserved by using fine-grained films, and that color films are manufactured to correspond to different types of light.

Ultimately, photographers may reach a level of expertise where they become sensitive to the creative potential of films. At this stage, they develop the ability to merge the technical and creative capabilities of films.

The purpose of this project is to help you understand some of the important characteristics of films in order to improve your technical as well as your creative competence in handling photographic film.

WHAT YOU NEED TO KNOW

GRAIN

In the process of forming a photographic image, molecules of developed silver clump together in clusters. The overall appearance of these clusters on film or photographic paper is called "grain," and varies from film to film. The size of the clusters relates directly to how sensitive the film is to light: the smaller the amount of light a film needs in order to form an image, the larger the clusters of silver that are formed.

GRAIN AND ENLARGEMENTS

Except for special purpose, extremely fast films, grain in a negative is not apparent to the unaided eye. However, when an image is enlarged in the process of being printed or projected, the grain becomes noticeable when the degree of enlargement increases beyond a certain point. That point changes depending on how large the grain structure was in the negative. When extreme enlargements are to be made, using the slow, fine-grained films such as Panatomic-X and Plus-X by Kodak and Pan F or FP 4 by Ilford is almost mandatory if a sharp black-and-white image is to be generated from 35mm film. In the case of 35mm color film, when detail is absolutely critical, no film can equal the image sharpness of Kodachrome 25.

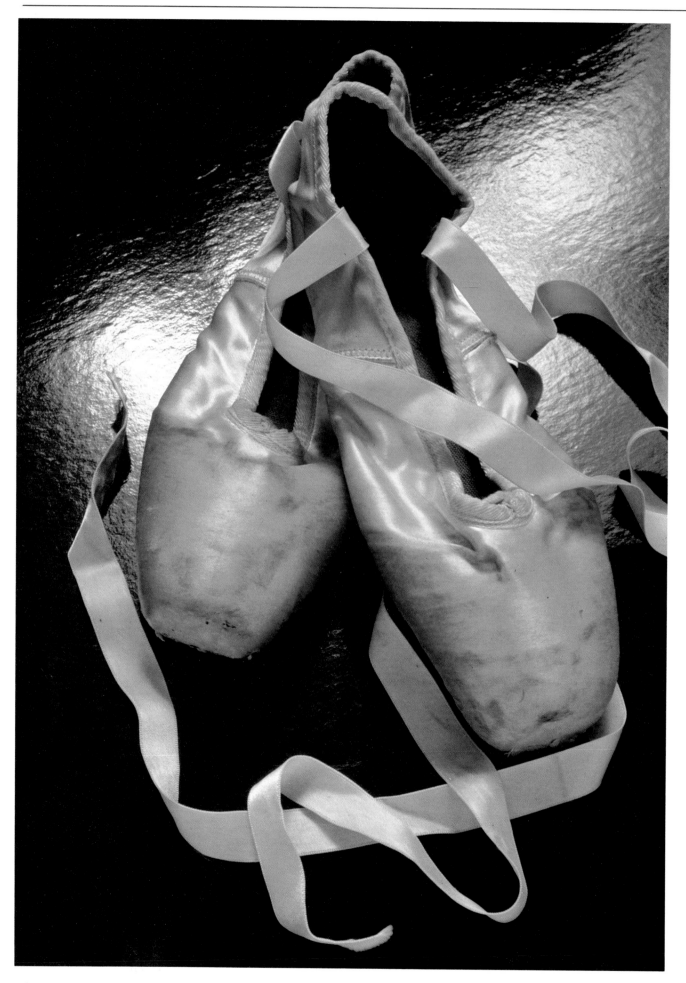

Kodachrome 25 film yields an exceptionally fine-grained 35mm image. When that film is combined with other detail-preserving techniques, the image-quality attained compares favorably with larger format films. In this photograph Kodachrome 25 film combined with the extreme depth of field possible with electronic strobe lighting produced an exceptionally sharp image. This photograph could be enlarged to as much as 16" × 20" (41 × 51 cm) without the grain becoming apparent.

FILM SPEED RATINGS

Traditionally, film speed has been rated in terms of ASA and DIN numbers (e.g., ASA 32/16 DIN). Recently, the International Standards Organization has devised a new rating convention (e.g., ISO 32/16°) which will eventually be used universally.

During a transition period, film boxes will list film-speed ratings using both old and new conventions.

CAMERA FORMAT

Kodachrome 25 is unique among color films. It has such fine grain that a 35mm Kodachrome 25 enlargement will not show any more evidence of grain than a 2 1/4-square Ekta-chrome (or equivalent films from other manufacturers) enlargement of the same final size. As a result, 35mm and 2 1/4-square camera formats are interchangeable in terms of color image sharpness. (Kodachrome film is only manufactured in 35mm size.)

In order to achieve in black and white the same degree of sharpness that is possible with Kodachrome 25, the black-and-white negative must be larger to start with. Therefore, when fine detail is critical in a black-and-white enlargement, the film can be no smaller than 6 cm × 4.5 cm (2 1/4" × 1 5/8"). For moderate enlargements or in instances when the presence of noticeable grain is unimportant or even desirable, 35mm black-and-white film will usually be adequate.

COLOR BALANCE

Not all light sources produce light of the same color. As a result, color films are "balanced" so that they will render colors correctly in the presence of a particular light source. If you use a film that is not balanced for the light source you are using, a color shift occurs over the entire frame of film.

The color "temperature"—designated in degrees "Kelvin"—assigned to a particular light determines the correct color film to use. There are two main categories of color film: daylight, for use in sunlight or in the presence of electronic flash; and tungsten, for use with incandescent lamps. Within the tungsten category are two subdivisions: film for lamps with a color temperature of 3200 K; and film for lamps with a color temperature of 3400 K.

When your goal in using color film is to record the colors present in a scene as accurately as possible, then you must match film and light source carefully. However, in some circumstances you can intentionally mismatch film for creative effect.

Tungsten film used in daylight or with electronic flash assumes an overall blue cast, while daylight film used with tungsten lighting appears to be yellow. Although the color shifts are distinctly noticeable, they are not so radical that they always produce a jarring visual effect. Instead, a shift can be pleasing when it complements the mood of a photograph.

PUSHING FILM

The ASA rating assigned to a film is the manufacturer's suggestion as to the amount of light which will result in the best image possible being formed on the film. When film is exposed to less light than the manufacturer recommends, grain increases and detail is lost in highlights and shadows. If the film is developed normally, image deterioration can be significant, but if the amount of time the film is left in the developer is increased by a designated amount, the deterioration can be minimized.

Exposing film as if it had a higher ASA rating than the manufacturer assigned and then developing the film longer than usual is called "pushing" film. (Most processing labs will process pushed film for an additional fee, but you must be certain to inform them in advance of how many *f*-stops you pushed the film.) In most circumstances, pushing a roll of film one *f*-stop,

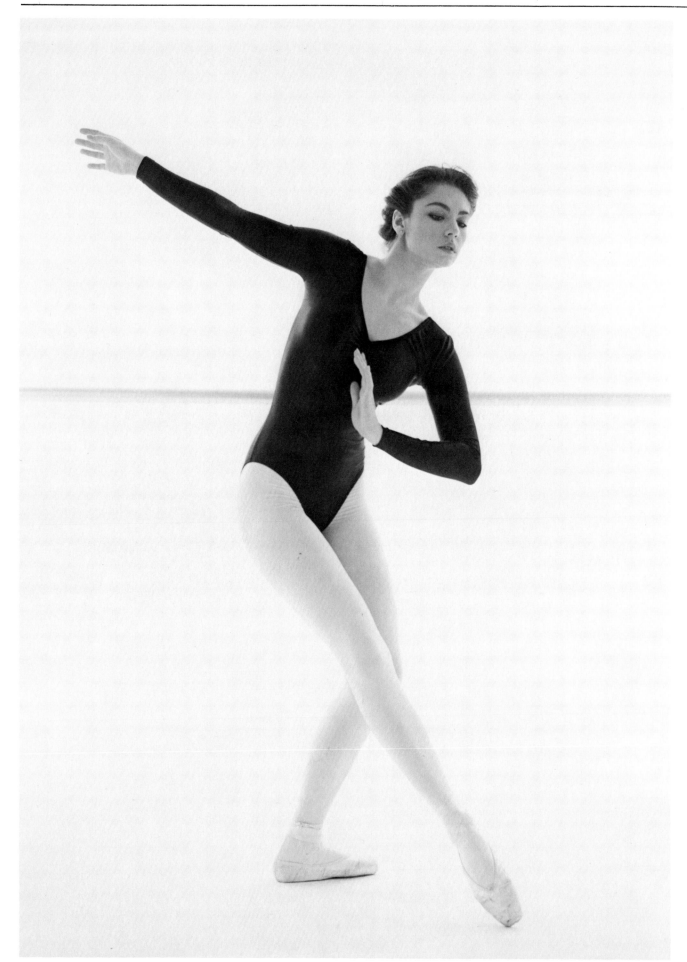

Different films can have a marked effect on the appearance of a photograph and the statement it makes about its subject. At left, because the goal was to produce as finely detailed an image as possible, Panatomic-X film was used in a 2¼-square camera. Notice how sharp the image is, and how much detail is apparent in the dark and light areas— even wrinkles in the dancer's leotard and tights are clearly visible.

At right, because the goal was to produce a grainy image, the dancer was shot on Kodak Recording Film (an extremely high-speed film designed for police surveillance work) with a 35mm camera. The resulting image lacks the sharpness, contrast, and detail present in the other photographs, but has a light, airy feeling.

The photograph at left is a better portrait of the individual dancer, while the photograph at right makes a better photographic statement about dance and the dancer.

i.e., exposing the film at double its assigned ASA rating, will show a minimal (albeit noticeable) increase in grain and loss of contrast, while pushing the roll two *f*-stops will cause a major increase. Most films should not be pushed beyond two *f*-stops. Kodachrome cannot be pushed at all.

Large grain is not always to be avoided. In some situations graininess can create a light, airy feeling that is consistent with a particular mood. In such a situation, the increased grain caused by pushing film is an advantage.

YOUR PROJECT

Buy three different types of color film (e.g., Kodachrome 25, Ektachrome 160, and Ektachrome 400) and three different types of black-and-white film (e.g., films of ASA's of 32, 125, 400). Buy two rolls each of Ektachrome 400 and the high-speed black-and-white film.

Choose a subject or subjects, then:

1. On each type of film shoot to maximize detail (follow the procedures described in Project 17).

2. With the color films, shoot each subject with the film and light source correctly matched (pay attention to the light for which each film is balanced), then again with the film and light source intentionally mismatched.

3. With the second rolls of Ektachrome 400 and Tri-X, repeat your shots but shoot to maximize grain by pushing the films one or two *f*-stops. (Note that because the entire roll of film must be push processed, if one frame on a roll has been pushed, the rest of the roll must also be pushed.)

Evaluate your color results by making 8″ × 10″ (20 × 25 cm) prints or by examining them with 8× magnifying "lupe" (available from photo stores). Compare the color, grain, and contrast of each treatment, and notice especially the effect of the mismatches.

Evaluate your black-and-white results by making 8″ × 10″, 11″ × 14″ (28 × 36 cm), and 16″ × 20″ (41 × 51 cm) prints and evaluating the effect of film type and pushing on grain. (To save paper, you can print only a *portion* of a negative onto 8″ × 10″ sheets of paper to produce the *equivalent* 11″ × 14″ and 16″ × 20″ enlargements.) Study the enlargements to determine the extent to which each type of film can be enlarged before the image begins to break down due to increased grain size.

A SAMPLE PROJECT

The photographs in this project are typical of the results you may encounter. Notice in particular the feeling that results from the color shift in the photograph of the ballerina lacing her slippers, and the effect of the presence of grain and lowered contrast in the black-and-white photographs.

The proportionate increase in size an image undergoes when prints are made can be substantial and depends upon the size of the original negative. The figure at right and the chart below illustrate some of the proportions involved.

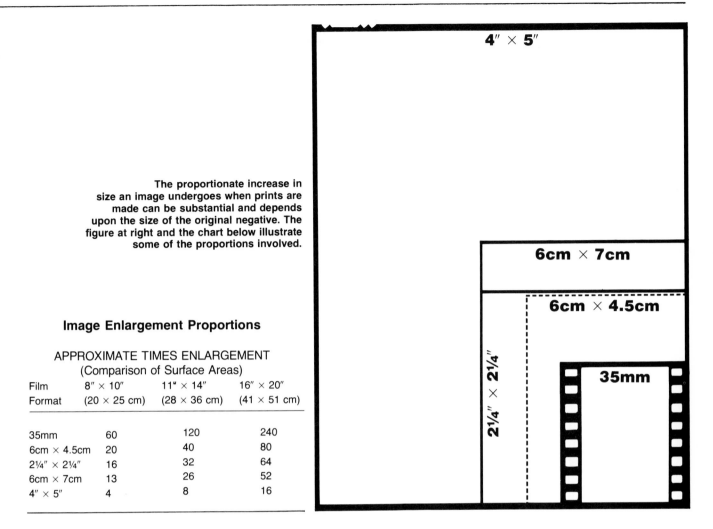

Image Enlargement Proportions

APPROXIMATE TIMES ENLARGEMENT
(Comparison of Surface Areas)

Film Format	8″ × 10″ (20 × 25 cm)	11″ × 14″ (28 × 36 cm)	16″ × 20″ (41 × 51 cm)
35mm	60	120	240
6cm × 4.5cm	20	40	80
2¼″ × 2¼″	16	32	64
6cm × 7cm	13	26	52
4″ × 5″	4	8	16

Unless the subject is relating to his or her surroundings in a natural way, he or she will usually appear awkward on film (frames 33 through 36A). Because the camera imposes a degree of artificiality, which most subjects at first find difficult to ignore, you must coax your subjects into behaving as they would if a photographer were not present. Frames 3 through 7 were taken with a 21mm lens to relate the author to as many of the elements in the room as possible. The extreme depth of field characteristic of such a wide-angle lens preserved sharpness in the background, revealing excellent detail in the books. By being given a book to hold, the subject had something to occupy his hands that contributed to his assuming a relaxed posture, and also reflected his interest in books.

Switching to a 35mm lens (frames 18 through 22) eliminated the converging lines produced by the shorter lens and increased the subject's size in the frame. Moreover, as the subject became more comfortable with the camera, he began to behave more naturally. When he spontaneously started to lean back, a slight change in camera position permitted his head to become well defined against the white wall in the background. In frame 20 (shown enlarged on page 63) the subject still occupies only a small area of the total frame, but nonetheless dominates the photograph.

No matter how successful the first shots might seem, experimenting with additional lenses is usually worth the effort. The 50mm lens used for these shots threw the background partially out of focus, thereby shifting some of the emphasis away from the background and onto the subject himself. In addition, the somewhat longer lens increased the size of the man's face in the frame so that his features are more clearly discernible.

9 | JOURNALISTIC PORTRAIT

From the very earliest days of photography, the camera has been used for taking photographs of individuals. Usually, these were classic portraits intended only to show what a person looked like. A *journalistic* portrait, however, seeks not only to capture a person's likeness but, in addition, to reveal something about a subject's personality and the characteristics of his or her life. As a result, the environment surrounding the subject of a journalistic portrait often is nearly as important as the person being photographed.

The purpose of this project is not to turn you into a photo-journalist, but to help you learn to relate the subject of a photograph to its environment. For no matter what the subject, a skilled photographer makes certain that all the elements in a photograph support his or her subject properly.

WHAT YOU NEED TO KNOW

EQUIPMENT

Film. Because journalistic portraits are not taken in a studio, you may not have much control over lighting and should carry a variety of films, from very slow to extremely fast. If you have your own darkroom or have access to a commercial processing lab, you have the additional option to "push" films. That is, you can expose them as if they had a higher ASA rating than that assigned by the manufacturer, and then compensate by allowing extra development time, as discussed in Project 8. Even if you are planning to shoot in black and white, carry some color film, just in case.

Lenses. For reasons discussed in detail below, you should carry any lenses in the range from wide-angle (20mm–35mm) through normal (50mm–55mm) to portrait (85mm–105mm). (These focal lengths apply to 35mm-format cameras only, and must be scaled appropriately for 2 1/4-square or other formats.)

Light sources. Because you are attempting in a journalistic portrait to show a subject as "honestly" as possible, artificial lighting in general should *supplement* available light rather than overwhelm or replace it. Portable electronic flash units and small quartz lights mounted on stands are usually adequate for the task.

The electronic flash unit need not be large and its light can usually be "softened" by bouncing it off the ceiling. (With color film the ceiling must be white or color shifts will occur.) However, you must experiment to know in advance how exposure will be affected.

Light bounced from a ceiling is very smooth but strikes the subject from an unusual angle. Bouncing light into a reflector umbrella (see photo) produces a more natural light angle and at the same time helps to give a face character by generating a more directional light.

Tripod. At the slow shutter speeds often necessary to take a journalistic portrait, a tripod is often required to help prevent motion blur.

LENS DISTORTION

The size relationships between near objects and far objects in a photograph depend solely on the location of the camera and not upon the focal length of the lens being used (as long as the lens is "rectilinear"; i.e., not a fisheye lens). At a distance of from four feet (1.2m) to six feet (1.8m) from an object, no apparent distortion will occur, regardless of lens focal length. To avoid distortion, you should stand between four and six feet from your subject, and select the lens that will encompass the amount of background you want to include in the shot. As you move outside that range, distortion will become progressively greater. The effects are much more apparent when you move too close to your subject than when you move too far away.

RELATING SUBJECT TO BACKGROUND

Your choice of lens will directly affect the relationship between the subject of the portrait and the other items included within the frame.

Because of its broad depth of field, a wide-angle lens will render the background behind your subject in sharp focus. As

Traditionally, formal portraits are presented in a vertical format. The horizontal format is used here in order to maintain a correct subject-to-camera distance for proper perspective and, in addition, lends the portrait a degree of informality appropriate to a journalistic portrait. In addition, the horizontal format reinforces the story-telling role of the photograph by leaving at least half of the frame available for the inclusion of something other than the subject's head. In this example, the format enabled the subject's hands to be captured in a natural, expressive configuration suggestive of the man's personality.

Portrait lenses held at the correct distance to provide proper perspective will crop a photograph tightly around a person's head and shoulders. Combining such tight cropping with the limited depth of field produced by portrait lenses diminishes opportunities for relating subjects to their surroundings. Nonetheless, in any journalistic portrait session, a few shots taken with a portrait lens can insure that at least one portrait will show the subject's features very distinctly.

In addition, often a close-up portrait and a journalistic portrait can be used together for illustrating a magazine or newspaper article. Or, as in this case, the close-up portrait could be used on the flap of one of the writer's books.

Sometimes there will not be enough available light present in a scene to allow you to use a shutter speed fast enough or a depth of field broad enough to meet your needs. In such circumstances, you can supplement available light with the simple setup shown above. The arrangement combines four separate elements: an umbrella reflector, a light, a stand, and a clamp. The umbrella can be any of the types sold by camera stores and supply houses. The lamp can be electronic flash, a photo flood, a photo spot, or, as shown here, a 650 watt quartz movie lamp. The stand can be a special unit or can be a simple tripod. And the clamp can be of the type sold along with some brands of umbrellas or can be purchased separately.

The advantage of the arrangement shown is that it is compact, portable, inexpensive, and easy to set up. Moreover, the umbrella casts a light that is relatively broad but which still retains some directionality. With a quartz bulb, the system is powerful enough to illuminate a medium-sized room.

lens focal length increases, the background becomes progressively less distinct. With portrait lenses, unless you place your subject very near the background, background features will be practically unrecognizable. Thus, the lens you choose to use will often be determined by how closely the background relates logically to your subject. The closer the logical connection, the more distinct the background should be.

YOUR PROJECT

For a project, select people from three of the categories in the list below (or compile your own list). If you must use strangers as subjects, remember that many people will consent to pose for you in exchange for some free prints.

Try to obtain a good journalistic portrait of each subject using at least three different lenses. Take a wide-angle shot relating the subject to a pertinent background that is clearly recognizable, a medium shot in which the background is somewhat obscured, and a close-up portrait in which the background is completely out of focus.

Have your subjects perform activities that are familiar to them. Watch for expressive gestures which reveal personality.

Evaluate your results in terms of how clearly your shots capture the personalities and occupations of your subjects. If you have been successful, you should have at least two shots

of each subject that could be used in a magazine or newspaper article about the subject.

Doctor	Teacher
Lawyer	Druggist
Firefighter	Grocer
Construction Worker	Artist or Artisan
Letter Carrier	Athlete

A SAMPLE PROJECT

The first step in taking a journalistic portrait is to become familiar with the subject's surroundings. In our example, the subject was asked to conduct a short tour of all rooms in his apartment. The subject, Frank Hercules, a distinguished writer, immediately showed by his actions that his study was his favorite area within his apartment. Moreover, the books lining the walls and stacked on the floor constituted a logical backdrop for his portrait.

At first, most people not accustomed to being photographed feel ill at ease in front of a camera. Therefore, the best approach is to begin a shooting by simply familiarizing the subject with the sound of the camera's shutter without being too concerned about the amount of film you might seem to be "wasting." The subject of the sample project was better than many, and by the end of the first half roll had become reasonably relaxed (see contact prints on previous page), but many subjects require more time before they lose their self-consciousness.

Rarely, if ever, should you consider a shooting complete before you have exposed at least a few frames through each lens you are carrying and until you have moved your subject into a variety of different settings. In this sample project, moving into the man's living room dictated a different lens because the background was no longer pertinent to his life. He was standing in his own home and the items on the wall were his, but they did not reveal his personality as clearly as did the books. Therefore, the selective focus capability of the 50mm lens provided a means for de-emphasizing distracting background details without obscuring them entirely. Camera position was intentionally chosen to make the background elements serve more as compositional aids than as story-telling details.

After the living room session, the subject was taken outside into harsh, midday conditions. Different locations and lenses were tried, but it was difficult to relate the subject to his occupation outdoors. Although several exposures were made with the city as a backdrop, none was as successful as the one taken against the shaded wall of a nearby building. The 90mm lens used produced a photograph that is more nearly a traditional rather than a journalistic portrait, but at least the narrow depth of field of the lens threw the background sufficiently out of focus to obscure it without causing the photograph to seem as if it had been taken in a studio.

Of all the exposures made in the
course of the shooting, this print
best fulfills the goals of a
journalistic portrait. The subject
is clearly shown, he is situated in
a setting appropriate to his
occupation, and his figure relates
well to his surroundings. Perhaps
most important, thematically the
photograph gives the impression
that the man was sitting at his
desk chatting with someone who
just happened to take his portrait.
After gazing at the photograph,
we feel we know something about
the subject's personality
and his life.

10 | COMPOSITIONAL FRAMING

A strong frame focuses attention on a subject and adds interest.
The view of New York's Chrysler Building below is properly exposed and perfectly acceptable technically, but is a noticeably inferior photograph compared to the one at left.
At left, the frame serves a variety of functions. Immediately apparent is the way the frame directs the eye to the buildings. The effect is so strong that even though the buildings at left occupy proportionately less space in the frame than the buildings below, their impact is equally as great. Compositionally, the shape of the frame complements and interacts with that of the buildings.
Sometimes frames are easy to locate, at other times you must search hard for them, as was the case here.

Photographers often concentrate so intently on the subject that they forget to consider other elements within a scene. In particular, it is easy to overlook the importance of using visual devices to control the eye movement of the ultimate viewer.

One of the most effective methods of controlling eye movement is through the use of a natural "frame," where foreground objects within a scene surround the main subject and direct attention to it.

Not every photograph needs framing, but in many instances the presence of a well-placed frame can make significant improvements. Conversely, a poorly conceived frame is worse than no frame at all.

WHAT YOU NEED TO KNOW

FUNCTIONS OF A FRAME

Controlling a viewer's eye movement. Although most people never think about the way their eyes move across the surface of a photograph, through the use of visual cues a photographer can entice a viewer's eye into exploring an image dynamically. This active involvement by the viewer makes a photograph more interesting to look at than one in which the eye rests immediately and solely on one single object.

Creating an illusion of depth. The flat surfaces on which photographic images are printed obscure distance relationships in a scene. A photograph that incorporates a foreground frame introduces a feeling of depth because the mind automatically recognizes that the foreground objects were closer to the camera than the main subject. In addition, often a frame can give a sense of the scale of the subject.

Echoing the subject's form. Prominent aspects of the form of the main subject can be mimicked in the object used to frame a photograph, thereby calling attention to those aspects. In this use, the frame is fulfilling primarily an artistic, compositional function. Even a frame with a form that *contrasts* with that of the subject directs attention to the subject's form.

Revealing detail. Often in travel or architectural photography, a structure becomes so small in the frame that details of the subject's design or construction may not be discernible. Using an object with a structure similar to that of the subject as a foreground frame can supply the missing information. (For example, a foreground wall might duplicate some of the structural details of a building shown in the background of a photograph.) Similarly, when shrubbery or trees are used to make a frame, they furnish information about the season in which the photograph was taken.

Obscuring distractions and dull areas. Frequently, objects that are present in a scene but which detract from the photograph can be hidden behind a frame. Alternatively, objects that are a distraction when standing alone can be successfully incorporated into the frame.

In a similar manner, large blank areas, such as a cloudless sky, an undecorated wall, or an empty patch of foreground, can often be hidden behind the object or objects that form a frame.

Adding interest to commonplace subjects. Some subjects have been photographed so often from the same vantage point that they have become boring. A novel frame can be an effective method for presenting one of these overworked subjects with a refreshing, new outlook.

STRONG VS. WEAK FRAMES

Despite any other functions it might perform, a frame that fails to lead a viewer's eye to the subject of a photograph is ill conceived and distracting. The shortcoming a frame is most likely to suffer from is that of being too "weak"; i.e., the objects being used to form the frame do not guide the eye to the subject. A common example of a weak frame is one that is simply a few leaves or the ends of a few tree branches intruding slightly into the photograph.

Less frequently, frames are too strong. A frame must serve its function without dominating or diluting the impact of the subject. Even when the frame is meant to provide information about the subject, that information should not compete too strongly with the subject for viewer attention.

Just how strong to make a frame is an aesthetic decision that must be made anew in every photograph.

YOUR PROJECT

Expose one or two rolls of film, either black and white or color, in which you photograph at least three different scenes (a building, a statue, and a landscape, for example) with no frame, with a weak frame, and with a strong frame. Pick at least one inherently dull subject and try to liven it up by choosing an imaginative frame. Practice using, at least once, each of the functions a frame can perform. Before you take each photograph, make sure that you have a clear idea in mind of which function you want the frame to perform.

Evaluate your results by comparing the photographs containing a frame to those you took without a frame. Note how distracting the weak frame is, and how much more powerful the strong frame is. In each case, ask yourself if the frame effectively directs your eye to the subject of your photograph, and if the presence of the frame actually improves the photograph.

Make a conscious effort whenever you take photographs to look for objects within a scene that you can use as a frame.

A SAMPLE PROJECT

A useful approach to framing is to walk around a subject and identify all the possible framing opportunities. Of course, with a subject like a landscape there is a limit to how much walking you can do but, in general, you should explore as much as necessary to avoid obvious and therefore uninteresting views.

Among the most readily available and easy-to-use items for framing a subject are tree branches, but you must be careful to make your frame "strong."
In the photo at left, the wispy tree branch in the left corner adds nothing to the photograph and actually detracts from it. The branch, like other "weak" frames, serves no informative or compositional function. The photograph would be better if the branch were not there.
Above, the branches surrounding the United Nations Secretariat Building do not compete with it, but encompass the building pleasingly. The branches add interest by filling the large blank area around the building, and immediately guide the eye to the photograph's subject. Without the branches, the photograph would appear somewhat sterile.

The photographs on these pages all resulted from a concerted effort to locate interesting frames. With a less systematic approach, many of the framing possibilities probably would have been overlooked.

An otherwise dull scene can often benefit from the inclusion of a frame.

The refinery could not stand alone very effectively. Between the overcast sky, the haze in the air, and the drab water, there is not much visual interest here.

By using the decaying structure of an old barge as a frame, the photograph has more appeal. A viewer's eye is unconsciously drawn from the barge to the background. The forms in the rotting wood echo the forms of the refinery. Moreover, the dark, looming bulk of the foreground provides a strong tonal contrast with the rest of the photograph and therefore gives the scene a more powerful feeling than the lighter gray tones, which otherwise would predominate.

Blur in a photograph to suggest motion can be produced by more than one technique.

In the photograph above, panning the camera horizontally in the direction the car was moving threw the background into a complete blur, which suggests the car's speed (and simultaneously hides distracting background details). The car itself remains blurred enough to suggest its motion, but panning preserves enough of the car's shape so that it remains recognizable. The hubs of the car's wheels, however, are appropriately blurred. Compositional devices also help. The upward angle of the car suggests its headlong thrusting motion, while the line along the roadway combined with an imaginary line running along the top of the car suggest the shape of an arrow.

BLUR MOTION

The fast shutter speeds of modern cameras have led many people to believe that fast is best. Certainly, fast shutter speeds are useful when the goal is to "freeze" motion and to eliminate the need to use a tripod to prevent motion blur due to camera shake. However, to experienced photographers, the shutter speed selected is as much a creative decision as a practical one.

Because the ability to suggest motion is well served by allowing the image to become blurred, creative photographers often prefer to employ an intentionally slow shutter speed.

Although producing motion blur is generally a matter of controlling shutter speed appropriately, the amount of blur that best suggests an object's motion involves subjective aesthetic judgments. Once the amount of blur desired has been determined, achieving that amount is primarily a matter of applying the knowledge gained from extensive experience in photographing moving objects.

WHAT YOU NEED TO KNOW

DETERMINING AMOUNT OF BLUR

When a shutter is open long enough for the image of a moving object to move perceptibly along the film plane before the shutter closes, a blurred image results. The longer the shutter remains open, the greater the amount of blur and the more abstract the final image. The amount of motion blur a subject should display lies somewhere between the amount necessary to *suggest* the speed at which the motion is taking place and the amount of blur that will render the object unrecognizable (assuming that a requirement is to be able to identify the literal subject of the photograph).

As a starting point, try to imagine the way the moving object actually appears to your unaided eye. For example, a race car's wheels turn too quickly for the words written on them to be discernible, but the words on the car itself, though blurred, are usually legible. The body of a helicopter is clearly identifiable, but its rotors seem to form a translucent disk. You may want to accentuate blur beyond your normal perception of it. Generally, however, less blur than the amount normally perceived will look unusual to a viewer (see photos of helicopter).

FACTORS AFFECTING SHUTTER SPEED

Object speed. Obviously, the faster an object is moving, the greater the amount of blur that will occur at a particular shutter speed.

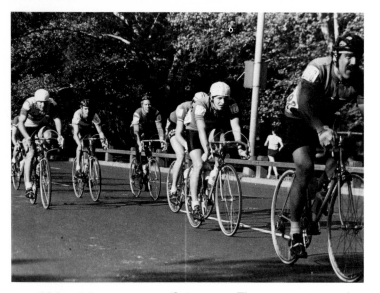

Object-to-camera distance. The nearer a moving object is to the camera, the greater the amount of blur that will occur at a particular shutter speed.

Lens focal length. The longer the focal length of the lens being used, the greater the amount of blur that will occur at a particular shutter speed.

Angle of motion. The more nearly parallel to the film plane the object is moving, the greater the amount of blur that will occur at a particular shutter speed. (An object moving directly toward or away from the camera induces comparatively little blur.)

Camera motion. If a hand-held camera is moved in the opposite direction to that in which the object is moving, the blur effect will be increased. Conversely, if camera motion is in the same direction as that of the moving object, the image of the object is held motionless against the film while the shutter is open, and blurring of the object's image on film is minimized or eliminated entirely.

PANNING

The technique whereby the camera "follows" the moving object is called *panning* and is an important tool in photographing motion.

Panning has two opposite effects. First, the object being followed displays substantially less blur than it would have shown had the camera been held still. Second, objects that are motionless in the scene or that are traveling more slowly or in a different direction from the panning motion display increased amounts of blur. In particular, motionless objects in the background of a scene become so blurred that they are usually unrecognizable.

Successful panning requires that the camera be following an object's motion during the entire time the shutter is open. You will obtain the best results if you start panning before you release the shutter and continue the panning motion until well after the shutter has closed.

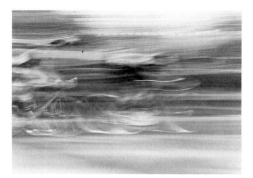

The shutter speed with which a photograph is taken can be critically important. At left, above, a 1/250 sec. shutter speed completely obscures the extreme effort the bicycle racers are expending. In the photograph, the cyclists look more as if they are on a sightseeing tour than in a race.
At right, above, panning the camera while shooting at 1/15 sec. produced a graphic feeling of motion. In this photograph, you can almost hear the "whoosh" speeding bicycles make when they pass. Immediately above, although the shutter speed was again 1/15 sec. panning slightly too fast resulted in an unusable photograph. To be safe, the best practice is to expose more than one frame at each shutter speed.

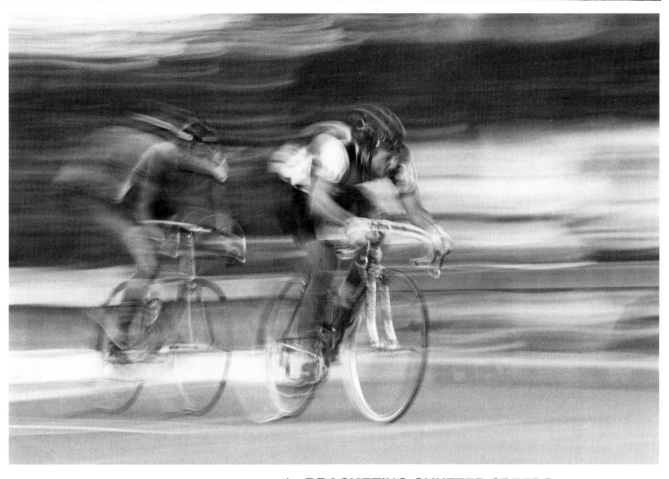

BRACKETING SHUTTER SPEEDS

In bracketing shutter speeds the intent is to photograph the same moving object at a variety of different shutter speeds to be certain that at least one shutter speed produces the desired amount of blur. Because of the element of random chance involved in blur motion and because of the large effect that unintentional camera motion can have on blurring, prudence dictates exposing more than one frame of film at each shutter speed.

YOUR PROJECT

To become familiar with the effects of blur and the technique of panning, have a friend jog or ride a bicycle in a circle around you. Following the motion with your camera, expose frames at shutter speeds from 1/500 sec. to 1/2 sec. on medium-speed film. (You may need to use a neutral density filter in order to be able to use the slow shutter speeds.) Also, expose some frames with your friend moving toward you and away from you and at various angles relative to the camera. Bracket your shutter speeds, take careful notes, and use the notes to study the effects of the different shutter speeds on your results.

Over a period of weeks or months, compile a collection of photographs that incorporate blur motion. (Sporting events are particularly good sources for motion shots.) In each situation, systematically experiment with different combinations of object speed, object-to-camera distance, lens focal length, angle of motion, and camera motion. Again, maintain careful records, and study your results in order to establish a "feel" for the best effects produced by the various combinations. With experi-

ence, you will be able to estimate by eye the approximate shutter speed to use in any situation and under any set of conditions.

A SAMPLE PROJECT

The photographs on these pages illustrate how dependent the selection of a shutter speed is on a variety of different factors. For the bicycles, the best shutter speed was 1/15 sec., while for the race car, the best was 1/250 sec. (Most people consider 1/250 sec. sufficiently fast to stop all motion, but that clearly was not the case with the fast-moving car.) The helicopter blade, which was moving even faster than the race car, was best shot at 1/60 sec. to produce the desired amount of blur.

The best shutter speed to use is usually one that will create a visual effect similar to that which the unaided eye normally perceives.

The blade of a flying helicopter is not visible to the eye. Therefore, a 1/1000 sec. shutter speed, which freezes the blade's motion (right), makes the helicopter appear to be falling from the sky.

A shutter speed of 1/60 sec. blurs the rotors just enough to imply their presence and suggest their motion. The difference in these two photographs, which were taken of the same helicopter within seconds of each other, is significant.

The red filter used to take the above photograph permitted the use of the slow shutter speed and at the same time darkened the sky. Note that panning the camera kept the body of the helicopter sharp, but blurred the clouds slightly.

Photographs taken against a seamless
background can appear dull unless you
control light carefully.
This photograph is successful because of
the way light sections of the chair are set
against dark sections of the background.
The gradual fall-off in the background from
light to dark results because the paper is
angled away from the light source.
The neutral background provided by the
seamless paper helps concentrate
attention on the interesting shape of the
chair.

12 | SEAMLESS BACKGROUNDS

Although a seamless effect seems mysterious to those unfamiliar with the technique, only a few items of equipment are necessary. Shown here is a nine-foot-(2.7-m) wide roll of seamless paper mounted on poles specifically designed for seamless photography. The vertical poles compress between the ceiling and floor, while the horizontal pole slips through the roll of paper. The smooth curve of the paper toward the camera is responsible for the characteristic look of photographs taken against a seamless background.

The background in a photograph is as much a part of the photograph as the primary subject. To control the background in a photograph completely, many photographers place objects on "seamless" paper, i.e., on large sheets of paper in which no seams are present.

Seamless backgrounds have the practical effect of eliminating the corners where floor and walls meet in a room. However, because seamless papers present nothing more to the camera than a flat area of uniform color (often gray), unless the paper is imaginatively lit, the presence of the seamless background will not enhance the photograph, and may even detract from it.

Those photographers who routinely use a seamless background do so to have a completely neutral background against which to work. Against such a background, the presence or absence of shading determines, for the most part, how successful the photograph will be. By learning to use seamless backgrounds, you will be able to employ a technique unique to photography. You will develop skills that you can use no matter what sort of background is present.

WHAT YOU NEED TO KNOW

NEUTRAL SURFACES

If you take a sheet of paper, curve it toward a camera, shine a bright light on it, and then bring the camera close enough to the paper so that its borders are not visible within the frame, the camera records only a smooth field which is uniform in tone. If you then place an object on the paper, the object will be standing against a neutral background.

Of course, if the paper and the object were both to display the same tone and if they were to be illuminated identically, the object would be indistinguishable from the paper. However, if you were to throw a shadow only on the paper, the object would suddenly stand out. In essence, this is how seamless photography works.

Rolls of seamless paper. The larger an object is, the larger the size of the seamless paper required. Specifically for the needs of photographers, art supply stores sell wide rolls of seamless paper in a range of different colors.

To use seamless paper rolls effectively, you need a means for suspending the roll near the ceiling of a room. Spring-loaded poles, which compress between floor and ceiling, are sold by photo supply stores (often by special order) for this purpose, or you can improvise your own. You also need a pole on which you can hang the roll of paper and then span the gap between the two vertical poles (see photo).

Minor changes in the relative positions of light and gobo can have major effects in the photograph.

At left, the horse does not stand out well from the background. Portions of the horse that are light in tone are lost against similar tones in the background.

Above, a gobo shades the background so that light tones in the horse correspond to dark tones in the background. The position of the gobo is illustrated in the photograph on the previous page.

Notice how much more depth the photograph above has compared to the one at left.

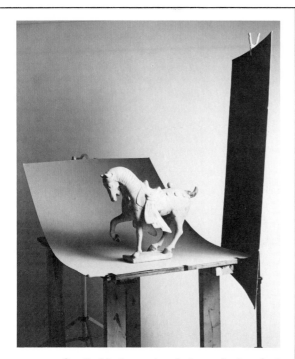

Small objects can be photographed against a sheet of high-quality cardboard. Notice how the gobo (the large sheet of cardboard on the right of the frame) is carefully positioned to throw a shadow on the background but not on the horse. The statue in this photograph is about as large as can be accommodated by a sheet of cardboard this size (26'' × 32'') (66 × 81cm). Because the statue was so large, a portrait lens had to be used to prevent the sides of the cardboard from appearing in the frame.

Before shooting, unroll the paper onto the floor (see photo), angling the paper toward the camera. The transition from vertical to horizontal should form a gentle curve, and the paper should be entirely free of creases or wrinkles. Once you have unrolled as much of the paper as you need, use a clamp to prevent the rest from unrolling.

In selecting a color, remember that black usually will not appear black but gray, and white will also appear gray unless you light it more strongly than you light your subject.

Seamless cardboard sheets. For photographing small objects, cardboard sheets are much easier to use than wide seamless rolls. Art supply stores sell cardboard sheets, which come in a much wider range of colors than roll paper.

To use cardboard sheets, you only need a horizontal surface on which to work. Depending on the angle at which you will be shooting, you can either lay the cardboard flat or support the end of the cardboard farthest from the camera so that, again, a gentle curve is formed. The object you are photographing must be small enough, and your lens must be long enough, so that the edges of the cardboard are not included within the frame.

REFLECTIVE BACKGROUNDS

Art supply stores also sell high-quality cardboard sheets with shiny, textured surfaces. You can produce some beautiful effects if you place an object on one of these sheets and then arrange your light so that you see its reflection in the cardboard's surface. By bending the cardboard and changing its curve, you can affect the shape of the reflection. In general, the larger and smoother your light source, the better the effect.

LIGHTING

Seamless backgrounds usually appear dull in a photograph unless you use lighting and shading imaginatively. Specifically, you can arrange your lighting so that light areas in your subject are set against dark areas in the background, and vice versa. Or, you can create a gradual increase in shading from light to dark along the background to make it more interesting and give it a feeling of having depth. As yet another alternative, you can cast shadows with interesting shapes onto the background (see Project 22).

You achieve these effects through the use of "gobos" to cast shadows and by carefully placing lights so that illumination that falls on the subject does not fall on the background, and illumination that falls on the background does not fall on the subject.

In general, your goal is to use combinations of lights, gobos, and reflectors to make certain that the subject of your photograph contrasts clearly with the background. There is no pat formula to help you learn to do this. Only by experimenting and studying your results carefully will you develop a feel for the relationships between light sources, gobos, and reflectors and the effects they produce.

Because a harsh light will often produce hard shadows on the seamless background, in general you should soften your light source by using an umbrella.

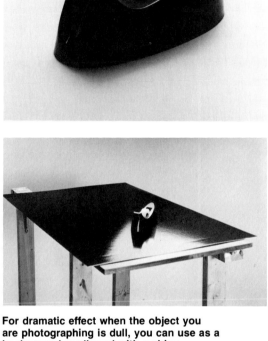

For dramatic effect when the object you are photographing is dull, you can use as a background cardboard with a shiny, textured surface.

The technique is similar to that shown on the previous pages, except that the light must be positioned behind the subject so that the image of the light reflects directly into the camera. In the photograph at left and the one above, the light-colored section underneath the tape dispenser is produced by the reflection of a corner of the light source.

YOUR PROJECT

Against either seamless roll paper or against a sheet of cardboard, photograph an inanimate object. Select a background color containing tones similar to those of the object. Light some frames without attempting to shade the background, then try to improve the photograph through the use of gobos and reflectors. Strive especially to show good visual separation between the object and the background.

A SAMPLE PROJECT

As you execute your project, notice how important it is to make the curves in the seamless material gentle. Sharp curves, wrinkles, or other irregularities will invariably show up in the final photograph.

If you experiment, you will find that usually it is easier to control background tone by shading a light color than by trying to brighten a dark color. In the photograph of the horse, the horse's tone was actually fairly close to that of the background.

In many instances the distance you place an object from the background can be important. If the object is too close, you will not be able to shade the background without also affecting the object.

Large seamless paper is a specialized material primarily used by still-life photographers but also used in fashion photography. For a good overview of the uses to which seamless backgrounds are put, study the ads in some of the national magazines.

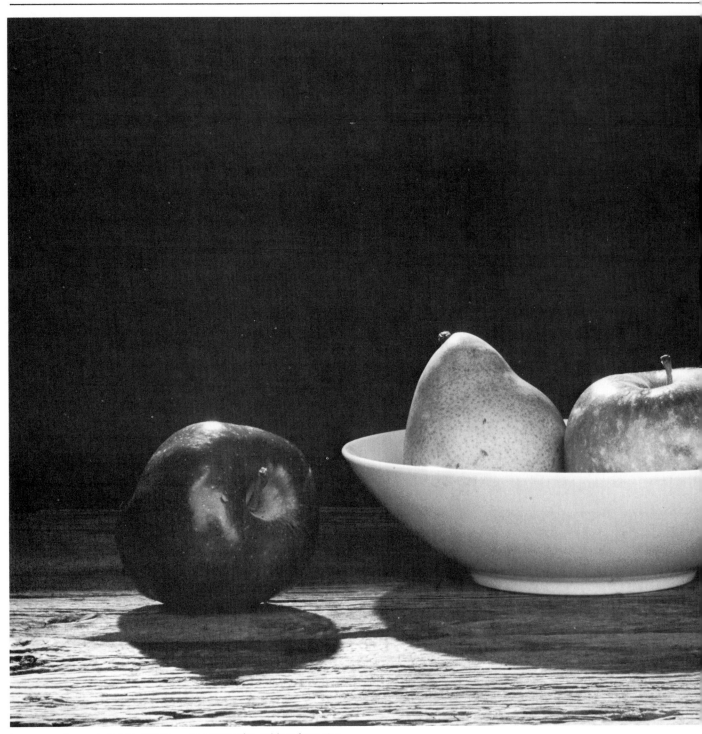

In a correctly executed backlight, the subject will be highlighted against the background, and sufficient reflected light will be present to provide detail in the front of the subject.

This photograph contains a full range of tones and retains all significant detail in highlight and shadows. Notice how the rimlight separates the subject from the background, and how the reflected light illuminates the front of the scene very evenly. The highlight on the front of the apple is a reflection of the white reflector, but is acceptable because the reflection helps emphasize the apple's form.

SINGLE BACKLIGHT

Many photographers habitually rely on at least two, and sometimes as many as four, separate light sources for a single photograph. In some specialized circumstances a multitude of lights may be indispensible, but one of the most versatile and flattering lights of all—a light that is relatively easy to produce and appropriate in a wide variety of indoor situations—is based on a single light used in conjunction with a few reflectors.

Properly handled, the light from a single lamp located behind the subject can bathe a person or an object in an exceptionally even, low-contrast light that is easily controlled and that gives consistently pleasing results. The technique seems complex at first glance, but is not difficult to learn and is extraordinarily useful.

WHAT YOU NEED TO KNOW

THE SETUP

If you were to place a lamp above and behind a subject—that is, with the lamp facing the camera and the subject in between—the outline of the subject would appear bright, but the side of the subject facing the camera would appear dark. The net effect would be a silhouette surrounded by a rim of bright light (a "rimlight").

If you were then to place reflectors so that they bounced light from the lamp onto the front of the subject, the silhouette would start to lighten up and fill in. As the intensity of the reflected light increased by making the reflectors larger or moving them closer to the subject, a point would eventually be reached where the reflected light falling on the front of the subject would be nearly as bright as the direct light illuminating the subject's outline.

Such are the conditions in a properly established backlight. The effect is to have a subject illuminated very evenly by the large surface area of the reflectors, and outlined by a rimlight.

ARRANGING THE COMPONENTS

Positioning lamp and background. In order to make sure that the subject contrasts well against the background, the background should be darker than the subject. Therefore, the lamp should be located *behind* the background, and the background should be short enough so that the lamp can shine over the background's top edge. Since the background will be farther from the reflectors than the subject, the background will appear comparatively dark.

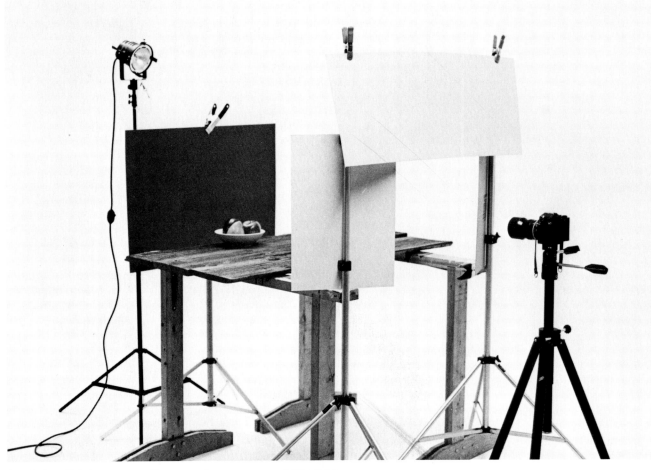

Few indoor lighting setups give better results with less equipment than the single backlight setup shown here. Although this arrangement may at first glance seem elaborate, with only a little practice it can be easily mastered. The most important characteristics of a single backlight are a sharp delineation of the subject against the background, and an exceptionally even light along the front of the subject. In addition, since the backlight casts a single shadow of the subject forward onto the foreground, backlit photographs usually have a clear feeling of depth.

Notice in the above photograph how the various elements of the setup are arranged. The light itself is located *behind* the background, and the background is positioned so that some direct light can fall on the subject. Reflectors on either side of the camera throw light onto the front of the subject and are bridged by a horizontal reflector which will both reflect light and, when lowered into position, block direct light from entering the camera lens. If more reflected light were needed, a fourth reflector could be added beneath the camera lens.

If only a few photographic stands had been available, the cardboard reflectors could have been folded and placed directly on the table.

Positioning the subject. The nearer the subject to the background, the brighter the background will be and the more it will be in focus. The distance to place the subject in front of the background will vary depending on conditions, but should be at least one foot (30 cm).

Positioning the reflectors. Where the reflectors are located has a strong effect on the photograph. If the reflectors encircle the subject (leaving only a gap through which the camera can point), the light they throw will be very even, creating essentially no shadows or shading. This arrangement is especially flattering for portraits made on color film.

If reflectors on one side of the subject are farther away than the reflectors on the other side, a "modeling effect" occurs whereby some shading appears to define features of the subject. Often some modeling of the subject is desirable with black-and-white film, since without the tonal variations contributed by color differences, black-and-white photographs can appear "flat" if the light is very even.

The effect produced by the reflectors depends also on their size. The larger they are, the more even the light they produce, and the greater its intensity.

Preventing lens flare. Because the light source is pointed directly at the camera lens, lens flare must be prevented or the photograph will suffer from greatly lowered contrast (see photo). The easiest way to prevent lens flare is to bridge the gap between the reflectors on the right and left sides of the subject with a horizontal reflective sheet, which both blocks ("gobos") direct light from entering the lens and throws additional light on the subject. Simply look at the front of the camera to make sure that the shadow formed by the horizontal reflector (the "gobo") is falling across the lens.

METERING THE SCENE

The difference between the intensities of the direct light falling on the back of the subject and the reflected light falling on the front of the subject is critical, and usually should be no more than one *f*-stop with color film and two *f*-stops with black-and-white film.

You should take two *incident* readings, both while holding the meter as close to the subject as possible. (See the *Appendix* for how to take incident readings using a reflective meter.) Take one reading with the meter pointing directly at the lamp, the other with the meter pointing directly at the front reflectors (be sure no direct light enters the meter). Take the photograph using the exposure setting you obtained by reading off of the reflectors.

To adjust the relative intensities, you can raise or lower the lamp or change the position of the reflectors. Moving the lamp has less effect on the intensity of the reflected light than on the intensity of the direct light, while moving the reflectors affects the intensity of the reflected light only.

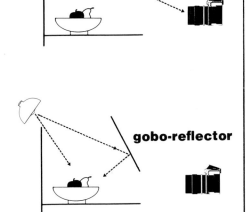

gobo-reflector

Unless the direct light coming from the light source is prevented from entering the camera lens, lens flare will result.

The easiest way to prevent lens flare is to position one of the reflectors so that it blocks direct light. When the reflector is positioned correctly, it will cast a noticeable shadow across the camera lens.

Backlight is a sophisticated lighting method that is as useful for portraits and other large subjects as it is for small still lifes like this.

YOUR PROJECT

Set up and photograph a simple still life illuminated by a single backlight. Use both color film and black and white. With each film, take a series of exposures. In the first exposure, arrange the reflectors so that the difference between the direct reading and the reflected reading equals one-half *f*-stop. In

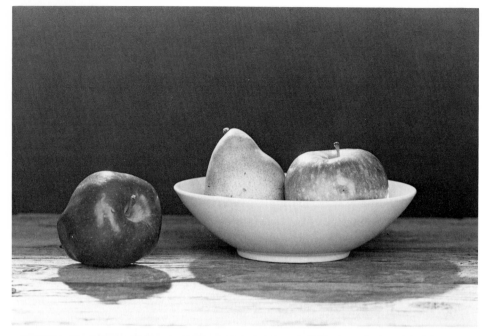

Lens flare causes a loss in contrast.
In this photograph, the "gobo" was in the wrong position and light directly entering the lens ruined the backlight effect. Notice how the range of contrast in the scene has diminished substantially.

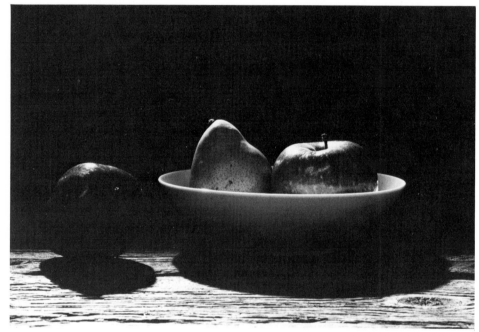

If the difference between the intensity of the rimlight is too much greater than that of the reflected light, contrast will be too extreme and detail will be lost. This photograph could have been saved by using larger reflectors, moving them in closer to the subject, by raising the height of the light source above the floor, or by a combination of all three. Had the photograph been exposed to give a proper exposure of the fruit, all detail would have been lost in the rimlit areas and in the foreground.

each succeeding exposure, move the reflectors sufficiently farther from the subject to increase the meter reading difference by one-half *f*-stop, until you have covered the entire range of meter reading differences from one-half *f*-stop to four *f*-stops inclusive. In some frames, remove the gobo to see the effects of lens flare. With the black-and-white film, expose enough frames with the reflectors at unequal distances from the subject to gain a feel for the effect of reflector distances on how well the subject is modeled.

When you have your results in hand, select the frames that show the best balance between the rimlight and the reflected light. As a guideline, remember that the rimlight should not be so overexposed that detail is lost. For later reference record the exposure differences that appear to you to give the best results.

A SAMPLE PROJECT

The single backlight setup requires some experimentation, and no two setups are ever exactly the same. However, the procedure we followed in taking the photographs on these pages is typical.

First, the task was to establish the subject's relationship to the background. Because the subject was small, the background could be close. Second, the light was set up to provide the degree of rimlight desired. Third, the reflectors were set in place. Fourth, the gobo was positioned to eliminate lens flare. Finally, light readings were taken, and adjustments were made in the position of reflectors and light source until the proper light balance resulted.

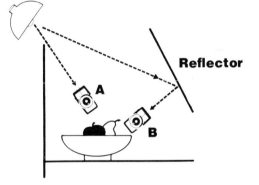

To determine whether the direct light and the reflected light are in proper balance, take separate *incident* light readings and compare. Be sure that when taking the reflected reading, no direct light enters the meter. When the lights are in correct balance (within one *f*-stop for color film and two for black and white), set the camera for the exposure obtained from the reading taken off of the reflectors.

A photograph of glassware is really a photograph of the *background.* To take the photograph at left, the glasses were lined up on a sheet of black Plexiglass in front of a sheet of white cardboard. Light shining on the sheet (photo below) passes through the glasses and is bent on its way to the camera, producing the highlights and shadows that form the image.
The Plexiglas reflects the whiteness of the wall and appears gray. The Plexiglas forms a single-image reflection of the glasses, unlike a mirror, which would form a double-image reflection.
Stray reflections in the glassware would have spoiled the photograph (above).

TRANSLUCENT SUBJECTS

The way an item reacts to light depends on the materials from which the item is constructed. To be skilled in photography requires that a photographer be aware of, and pay attention to, how all of the items in a scene respond to light. However, since most items photographers encounter are opaque and not especially shiny, they often ignore the effects of variations in materials and try to apply standard lighting techniques to subjects that do not interact with light in standard ways.

Glass is a classic example of a material that reacts with light in an unusual manner. The notable characteristic of glass is that it *passes* light, not that it *reflects* light. Therefore, the key to photographing glassware is to photograph not the item itself, but the light shining through it.

WHAT YOU NEED TO KNOW

BACKGROUND

When you photograph a glass object, you are really taking a photograph of the background located *behind* the glass. In the process of passing through the glass, the light originating from the background is bent by the curves and irregularities in the glass and produces the image of the glass on the film. You focus your camera on the glass, but it is the background light that forms the image.

The background should be light enough in color to throw light through the item of glassware and into the camera. Even black backgrounds are possible with the use of a technique often used by commercial photographers. By placing a small sheet of white cardboard immediately behind the item and slanting the cardboard upward at a 45-degree angle, light shining down on the item from above will be reflected through the glass into the camera. The size and exact position of the reflector must be determined by trial and error, but the technique permits the glassware to be illuminated distinctly against black.

REFLECTIONS

Glass reflects as well as transmits light, but generally reflections in glassware constitute a distraction. The items producing the reflection are often identifiable or confusing, and the presence of the reflection usually obstructs the light passing through the glass which otherwise would reveal the structure of the glass item. A single, unidentifiable reflected highlight on one side of an item of glassware can help convey its three-dimensional form, but otherwise you should eliminate reflections in glassware by covering the source of the reflections with black cloth or cardboard.

METERING

Since the subject of a glassware photograph is really the background, you should take your light readings off of the background rather than off the item of glassware itself. Thus, if the background is a sunset, you should set your camera for a correct exposure of the sunset (see Project 19). If the background is a surface with light falling on it, you need to expose for that surface.

YOUR PROJECT

Photograph an item of glassware against both a light background and a dark background. Illuminate the item in some photographs from the front, and in others from the back. Make sure that the item is completely defined by the light.

Evaluate your results in terms of how thoroughly you were able to eliminate all reflections in the backlit photographs. Also, check to see that the outline of the item clearly contrasts with the background.

For an advanced project, photograph a glass containing wine held in a person's hand, with a sunset as the background.

A SAMPLE PROJECT

To eliminate reflections, all room lights were turned off, and light-colored objects were covered with black cloth. The light shining on the background in some of the photographs was located under the table on which the glasses were placed.

In the photograph of the glasses it was necessary to place sheets of black cardboard on both sides of the glasses, but immediately outside the frame of the photograph, in such a way that the missing sections of outline were delineated. The exact position of the cardboard was determined by experimentation.

In the mug photographs, the shape and position of the reflector behind the mug also was determined by trial and error until the entire mug was illuminated without any of the paper showing.

If the background is dark, some means is necessary for directing light through the glassware.

In the photographs on this page, the light source is located above the mug. In the photograph at right, only the head on the beer is clearly defined.

A sheet of paper placed behind the mug and angled upward reflects the light through the mug and into the camera (see photo, left). As a result, the mug and its contents become illuminated effectively.

The black background is produced by using black velvet. While black paper or cardboard reflects enough light to appear gray in a photograph, the texture of the velvet traps all light, producing the jet-black color present here.

When photographing a shiny object, you are really photographing not the object itself, but the images reflected in it.
In a curved object such as the teapot shown here, nearly everything present in a room can show up as recognizable images—sometimes more than once. If you study the photograph above, you will be able to see two images of the umbrella reflector used to light the scene, the photographer and his camera, and miscellaneous items located in the room.
Just as important, the *shape* of the reflection conflicts with and detracts from the graceful form of the teapot, making it look short and squat.

The careful placement of large, white reflectors can make a radical difference in the way a shiny object looks in a photograph.
Compare this version of the teapot with the one at left. The white areas reflected in the silver surface now complement the shape of the teapot and enhance its natural elegance.
Although, by looking closely, you can still discern the camera lens within the dark section in the middle of the teapot, the lens is no longer readily apparent and does not constitute a distraction.

REFLECTIVE SUBJECTS

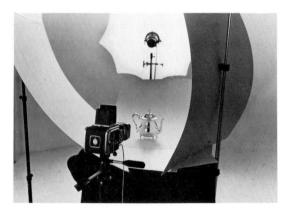

Arriving at the setup necessary to obtain the photograph on the right side of the previous page required a substantial amount of experimentation.
In the photograph above, which shows the final setup, note that the camera is in the opening, but because of the distorting effect of the teapot's shape, the camera's image is not recognizable.
In order to avoid random reflections from appearing, all room lights were turned off during the exposure. Because of the fall-off in light intensity where there are no reflectors, the gaps between reflectors appear in the final photograph as dark areas on the surface of the teapot.

In a sense, a photograph is not really a record of an object, but of the way that object reflects and transmits light. An object that does not reflect or transmit at least *some* light cannot be photographed; the object produces nothing that can interact with film to form an image.

The surfaces of most objects are irregular and to a greater or lesser extent disperse light in the process of reflecting it. However, shiny objects leave the light they reflect virtually unchanged. Similarly, when the surfaces of metal objects become scratched, the scratches reflect light and become very apparent. Thus, the need to control those reflections makes photographing shiny objects a special challenge.

Reflective objects appear in photographs more frequently than the casual photographer realizes; however, with the exception of commercial still-life photographers, relatively few people know how to handle shiny objects when they are present in a scene. Because reflective objects may be present any time, the ability to spot them and control them is a telling measure of a photographer's skill.

This project is one of the most difficult in this book, but the process of producing a good image of a highly reflective object will teach you an awareness of the nature of light and its control in photography that you will draw upon for as long as you continue to take photographs.

WHAT YOU NEED TO KNOW

THE EFFECT OF REFLECTIONS

That shiny objects are highly reflective would not be such a problem were it not for the effect the reflective images produce.

The most obvious effect is the appearance of an identifiable image. Every photographer has experienced the annoyance—even embarrassment—of seeing in a photograph the burst of a flash reflected by a window in a room. Shiny objects will reflect whatever is in front of them: people, lights, even the photographer.

Equally as important, reflections can either enhance or detract from the way an object is delineated and defined within a photograph. Random reflections are almost invariably distracting to a viewer. Nearly as frequently, uncontrolled reflections actually change the appearance of an object, making it display a distorted form or shape.

CONTROLLING REFLECTIONS

The dilemma in photographing shiny objects is that whatever you use to illuminate the object will be reflected by its surface, so the only way to eliminate the reflections seems to be to

Shining a hard light onto a reflective object produces glare and emphasizes blemishes and irregularities in the object's surface. The coin above was lit as shown in the photograph below. Even though to the unaided eye the coin appeared to be almost free of blemishes, the hard, direct light made the mars and scratches immediately noticeable.

Surrounding a small reflective object with a tent of translucent material reduces glare and minimizes the visual impact of surface blemishes (above).

In the photograph below, frosted Mylar has been rolled into a cone and placed over the coin. Two lights, the one shown and a similar light on the other side of the tent, produce an even light inside the tent that the coin reflects into the camera lens. Sometimes the opening for the camera to look through must be cut in the side of the tent.

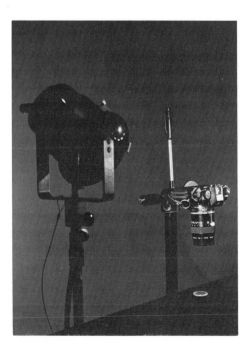

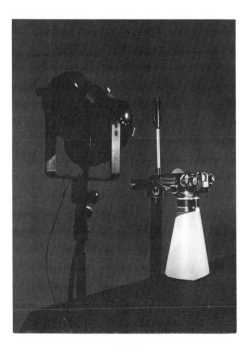

eliminate light. But without light, you will have no photograph at all. Therefore, the only solution is to manipulate the items being reflected so that the reflections themselves serve to illuminate the object you are photographing without detracting from the photograph at the same time. This is done by making certain that the shiny object is reflecting the image of a large, white surface.

Tents. For small objects, the easiest way to provide an even, white surface is to build a "tent" around the subject and cut a small opening through which to poke the camera's lens. The tent is constructed of any translucent material: tracing paper and frosted Mylar (available from suppliers of acrylic and Plexiglas plastics, and sometimes from art supply stores) work especially well.

The technique is to roll the translucent material into a cone shape and place it over the object you are photographing. When you direct two photo lamps positioned opposite each other onto the material, the tent becomes a large, white surface, the image of which is reflected off the surface of the object and into the camera lens.

This technique is particularly useful when the surface of a shiny object is scratched or otherwise marred. A more direct light emphasizes the blemishes, while in a broad, smooth light the blemished and unblemished portions blend into each other.

Reflectors. Rather than attempt to construct tents around large objects, the technique usually used is to surround the object with large sheets of white cardboard, then direct an even light onto the sheets. It is the reflection of the sheets by the surface of the object that the camera records. Because the goal is to attain as smooth a light as possible on the cardboard, the light illuminating the cardboard often should be broadened by bouncing it into an umbrella.

Cardboard poses a problem not encountered with a tent: the seams between sheets sometimes appear. The problem usually can be solved by covering the seams with white tape, or by curving the cardboard to eliminate the need for one or more seams.

ADDING DEFINITION

Especially when photographing an object with a complex shape, having the object reflect only white surfaces can sometimes detract from revealing the object's shape or form as clearly as possible. In such situations the reflections of one or more pieces of black cardboard can help delineate an object's form. Particularly at the edges of the object, the black reflection can help prevent the white outline of the object from being lost against a white background.

Care must be taken, however, to make sure that the black inclusions do not look artificial, or are so complex in shape or pattern as to constitute a distraction.

CAMOUFLAGING THE CAMERA

No matter how carefully you have surrounded your subject with smooth white surfaces, one potential difficulty always remains: the reflection of the camera. Unless you are vigilant, you are liable to notice your camera's lens, (and even your own face) staring back at you in your finished prints. Sometimes the image of the camera is so small it is unobtrusive and only ap-

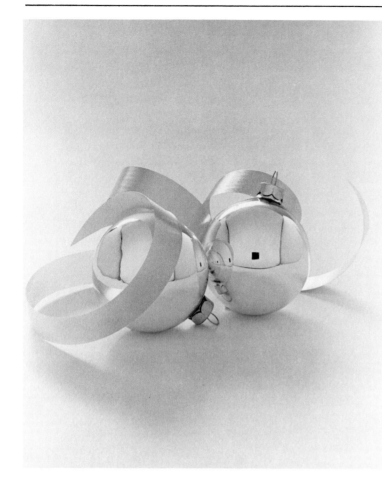

Curved objects are much harder to photograph than objects composed of flat surfaces.

The spherical shape of silver Christmas tree balls causes them to reflect anything visible within a wide arc. Moreover, because of the regularity of the spherical surface, most reflections are clearly identifiable.

The photograph at left illustrates some of the problems often encountered in photographing reflective surfaces. Even though attempts were made to surround the ball with smooth, white surfaces, the photograph does not "work." The pattern of the reflectors is evident because everywhere that two reflectors abut, a shadow results. Moreover, the pattern the lines form is distracting because the straight lines are incompatible with the curved shape of the balls. Finally, the opening for the camera lens to look through is obviously out of place in the photograph. (In the photograph above, the near reflector was placed against the table before the photograph at left was taken.) The ribbon in the photograph covers the reflection of the camera slit in one ball, and could have also covered the other slit, but the lines still detract substantially from the photograph. A technique similar to that used to photograph the teapot would be more successful.

parent if you are looking for it, but frequently the reflection can render an otherwise excellent photograph worthless.

One way to obscure your own reflection is to use a prop to cover the telltale image. The more elegant way is to camouflage it. Since the opening for your camera will appear as a black section against white surroundings, by changing the dimensions of the opening you can sometimes make the dark area appear natural. Or, occasionally, you can merely orient your subject in the frame so that your image is either obscured or so distorted that it is unrecognizable.

YOUR PROJECT

Photograph a shiny object. If you have little experience with reflections, start out by photographing a cylinder, such as a baby's sterling silver cup, or an aluminum pot. Use strips of black cardboard as well as white reflectors in order to create vertical striations and delineate the cylinder's three-dimensional form.

Next, photograph a shiny silver spoon. Be sure that your photograph incorporates a view of the inside of the bowl of the spoon. For purposes of comparison, photograph the spoon both without a tent and with one.

Evaluate your results in terms of how natural the object looks and how well its form is revealed. Did you eliminate all distracting reflections? Are surface blemishes obscured? Is your image or your camera's present?

For an advanced project, try to take a photograph of two silver Christmas tree balls in a manner such that the reflections in the balls emphasize their shape, and so that the image of the camera is obscured or camouflaged.

A SAMPLE PROJECT

The more complex the shape of a shiny object, the more difficult it is to photograph. In this sample project we have photographed a silver teapot instead of a spoon to illustrate better some of the problems you may encounter. Do not think, however, that photographing the spoon will be easy.

The primary challenge of photographing the teapot was to define its graceful shape and to hide the camera's reflection. A spherical object reflects images from such a wide angle of view that turning the pot to a different position did not solve the problems. After much experimentation, the recourse was to bend the reflectors and position them so that the gaps between them, which appear in the teapot as black areas on the surface of the pot, delineate its outline and obscure the camera in a dark area with a pleasing shape.

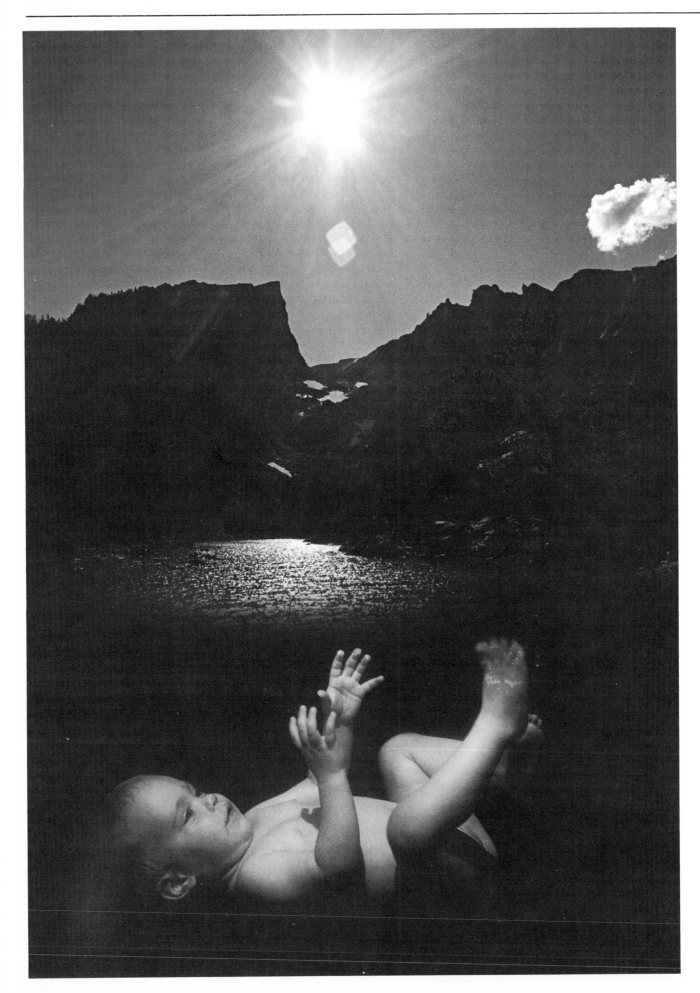

DOUBLE EXPOSURES

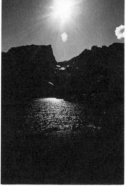

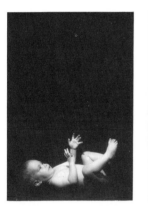

The two segments of a double exposure should be logically connected in some manner or else the photograph will look gimmicky.

In the photograph at left, an imaginary line running from the sun through the squares of lens flare across the surface of the water and into the infant's upstretched hands constitutes a logical as well as compositional connection.

The two photographs above show what each of the component scenes which went into the double exposure looked like when seen through the viewfinder.

A mask (shown below) was used to block out the lower part of the reflection on the water.

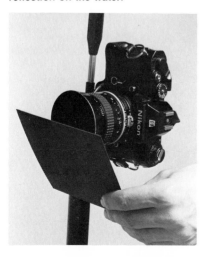

Photographs record light. All the light, however, need not have been deposited on the film at one time. When a frame of film is exposed more than once, the double or even multiple images formed can show individual events that occurred over an extended time interval on a single frame. Also, multiple exposures can simulate motion or movement, or permit the creation of compositions that would not otherwise be possible.

WHAT YOU NEED TO KNOW

PREPLANNING

If you take a photograph containing an image but also containing a large, dark area, the section of film corresponding to that dark area remains light sensitive. If you make a second exposure of a scene containing a dark area that corresponds to the location of the original image and contains an image that corresponds to the location of the original dark area, the two images will be recorded in different positions on the film and will not interfere with each other.

As should be apparent, the key to successful double exposures is to plan carefully the location of images and dark areas in succeeding exposures. Although it is sometimes possible to superimpose two images directly on top of each other with pleasing results, in general, light on light will result in overexposed images, and black on black will not record any image at all.

PRODUCING DARK AREAS

Scene selection. An obvious way to produce a dark area in a scene is to select a scene to photograph that already contains a dark section. The moon, for example, works well for making double exposures because it is surrounded by the dark night sky. Even when stars are present, the moon is comparatively so bright that a correct exposure for the moon will not leave the shutter open long enough for the stars to appear on the film. Another easy way to achieve a dark area in a photograph is to shoot into a direct sun (Project 18) so that everything else in a scene falls into silhouette.

External manipulation. By covering or *masking* a section of the lens when making an exposure, you can leave a portion of a frame of film unexposed. By then moving the mask to cover the section of the frame on which the first image was recorded, you can record a second image on the unexposed portion of the frame.

The masking device can be your hand, but a sheet of black cardboard usually will give better results. You should hold the cardboard close enough to the lens so that the edge of the cardboard is out of focus. If the exposure is long, you can achieve the same effect by wiggling the paper while the shutter is open. The goal in either case is to make certain that the edges merge smoothly into each other.

HANDLING THE FILM

To make a double exposure you will need some method for exposing the same frame of film twice. Some cameras have a double-exposure feature which allows you to operate the film-advance crank (to set the shutter) without moving the film. Other cameras employ a device that enables you to advance the film and then rewind it exactly one frame. Some cameras make no provision at all for double exposures. (If you are uncertain about your camera's capabilities, consult your owner's manual.)

For cameras without a double-exposure feature, the only alternative is to expose an entire roll of film, then run it through the camera again to make the second exposures. The technique is as follows:

1. Open the back of the camera.
2. Rotate the film-advance crank until it stops.
3. Insert the film as usual, feeding the leader onto the take-up spool.
4. Draw a line with a grease pencil on the film between the upper and lower sprocket pins on the take-up spool.
5. Close the camera back, proceed as usual, and shoot the entire roll of film (suggestion: draw sketches of the location of the image in each frame).
6. Rewind the film, but stop before you have wound the film leader into the cassette.
7. Open the back of the camera.
8. Rotate the film-advance crank until it stops.
9. Insert the film as usual, feeding the leader onto the take-up spool.
10. Align the film so that the line you made with the grease pencil connects the upper and lower sprocket pins on the take-up spool.
11. Close the camera back and double expose the roll, frame by frame.

This same procedure is useful anytime you want to double expose an entire roll of film, whether your camera has a double-exposure feature or not.

USING THE "BULB" SETTING

If you set your camera on a tripod and the shutter at the "bulb" setting, you can make your double exposure by setting an object or person in a dark room against a black background and making your successive exposures with an electronic flash. The object or person must be located in a different position on the frame each time.

You will be less likely to obtain overlapping images if you light only one side of the subject. If you make more than two exposures on the same frame to achieve a "stroboscopic" effect, you can light your subject fully for the last exposure.

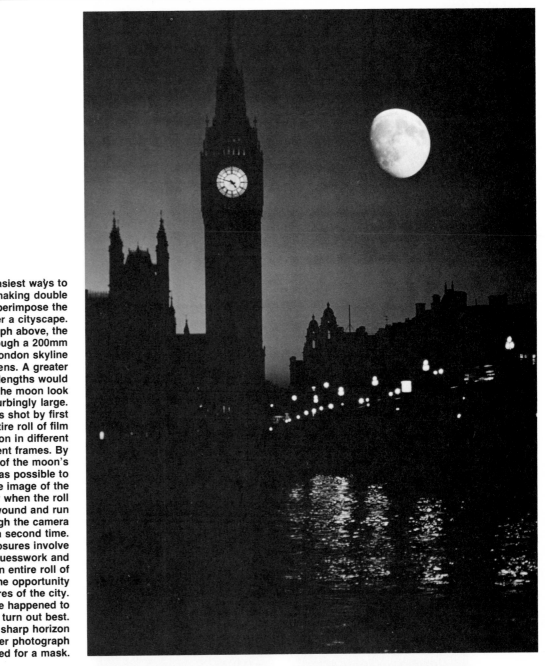

One of the easiest ways to practice making double exposures is to superimpose the moon over a cityscape.
In the photograph above, the moon was shot through a 200mm lens and the London skyline through a 50mm lens. A greater disparity in focal lengths would have made the moon look disturbingly large.
This scene was shot by first exposing an entire roll of film with the moon in different locations in different frames. By making sketches of the moon's position, it was possible to superimpose the image of the cityscape accurately when the roll of film was rewound and run through the camera a second time.
Since double exposures involve an element of guesswork and luck, having an entire roll of moons provided the opportunity to bracket exposures of the city. The one printed here happened to turn out best.
The absence of a sharp horizon line in either photograph eliminated the need for a mask.

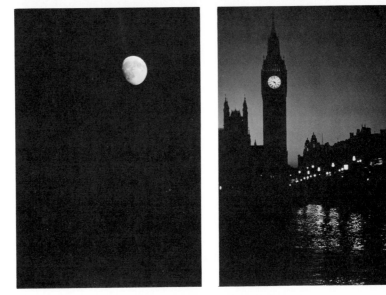

YOUR PROJECT

1. Expose an entire roll of black-and-white film with images of the moon (preferably taken with a 105mm or 200mm lens). Change the location of the moon from frame to frame and take notes to remind you later of the moon's position in each frame.

When you reinsert the film in the camera, take the second exposures of buildings, landscapes, seascapes, statues, or anything else you think will look good with a moon superimposed.

2. Make a double exposure containing a landscape and a person or part of a person's body. Use the mask technique and be sure to hide the mask's edge.

For an advanced project, demonstrate on film a continuous process using double-exposure techniques.

A SAMPLE PROJECT

The photographs shown on these pages required varying degrees of effort to produce.

The double exposure of the moon over London was fairly easy. Photographing the moon involves nothing more than pointing the camera and letting the camera select an exposure. For the cityscape, we used the procedures discussed in Project 4.

The landscape/baby photograph was more complex, both in concept and execution. The key ingredient here is that there appears to be a logical—albeit tenuous—connection between the two images. Many double exposures fail because they rely for effect only on novelty.

The photograph showing film agitation was a real challenge, but illustrates the concept of using multiple exposures to capture a sequence of events on one frame of film. The photograph combined the use of both continuous lighting and intermittent electronic flashes.

You can combine continuous room lighting with strobe flashes to create interesting effects or to demonstrate a process.
Here, the goal was to demonstrate the proper techniques for agitating film by inverting a developing tank over and back. The sequence could have been shown in three photographs, but multiple-exposure techniques permit the process to be shown more clearly in one photograph.
To take the photograph, a person's hand was passed through a slit in a background of black velveteen. To illustrate not only the three positions but also the movement involved, room lights were left on to cause streaking between successive positions. By popping an electronic flash three times during the exposure, the multiple images clearly show the positions of the hand and tank during the agitation process.
For this photograph a strobe unit was used that recharged rapidly enough to permit three flashes in quick succession. Slower flash units, such as those designed to be mounted directly on cameras, do not recharge as quickly and, therefore, place a limit on the speed of the motion that can be recorded in a multiple exposure.

17 | SCENICS

Since the earliest days of photography, scenes from nature have served as popular subjects. Even today some of the world's most highly regarded photographs are carefully crafted nature images taken by master photographers.

Almost without exception, great nature photographs are characterized by sharp detail throughout the entire photographic frame. In most instances, nature photographers achieve this sharpness by using sheet films that are 4″ × 5″ (10 × 13 cm), or larger. However, even for roll film in small-format cameras, techniques exist that can extract exceptional quality from a small negative and thereby approximate the degree of detail produced with the larger films.

WHAT YOU NEED TO KNOW

MAXIMIZING IMAGE SHARPNESS

In routine photographic situations there is usually little reason to worry about image sharpness. Modern films are sufficiently sensitive to permit shutter speeds and depths of field that are fast enough and broad enough, respectively, to yield acceptably sharp images under most outdoor conditions. However, in order to produce the extreme sharpness most nature photographers desire, special efforts are required.

Film choice. As film speed (as measured by ASA rating) increases, the size of the individual clumps of silver that form the photographic image also increases. To capture extreme detail, you need to use slow, fine-grained films. If you are photographing in black and white, Kodak Panatomic-X or Ilford Pan F are usually the films of choice. For color photography no film can match the image sharpness of Kodachrome 25.

Lens choice. Achieving quality nature photographs almost invariably demands that depth of field be as broad as possible. Since depth of field *in*creases as the focal length of the lens *de*creases, as a rule you will increase sharpness if you use the shorter focal length lenses to take nature photographs. Photographing animals is an exception to this rule. If you cannot approach your subject, you will need a telephoto lens. Normally, however, with a 35mm camera, a lens in the range of 28mm to 35mm makes an excellent choice for routine use, although you will often find that lenses of even shorter focal length can be useful as long as you are careful to watch for the distorted perspective wide-angle lenses can produce.

Lens aperture. Since an extensive depth of field is so important, in most circumstances you should employ the smallest possible *f*-stop on the lens you are using. Sometimes the

By being careful to maximize depth of field you can approximate on small-format film the exquisite detail routinely achieved by "view" cameras.

This photograph was taken on Plus-X film using a 35mm camera and a 35mm lens. In order to attain the greatest depth of field possible, the lens aperture was closed down all the way, the camera was mounted on a tripod (despite the brightness of the day), and the lens was focused at the hyperfocal distance. A red filter darkened the sky.

The detail in this image, which has been enlarged here to 8″ × 10″ (20 × 25cm), compares very favorably with the image quality that could have been attained with a 4″ × 5″ (10 × 13cm) negative. Had special attention not been paid to maximizing depth of field, either the grass in the foreground or the mountains in the background would have been out of focus.

As altitude increases and haze decreases, the sun becomes more intense and contrast problems become more severe. This photograph includes both brightly lit subjects and areas in dark shadow. At the time this photograph was taken the difference between the intensity of light on the rocks and in the woods did not seem extreme, but the film was unable to record detail in both at the same time without resorting to elaborate darkroom techniques. Since the camera's light meter read an average of the entire scene, in the final print the rocks are washed out and the woods is no more than an imposing block of darkness.

In such extreme lighting conditions such as these, the only remedies are to wait for a cloud to cover the sun and reduce contrast, to return at a different time when all sections of the scene are receiving less extreme intensities of light, or to compose the photograph to exclude areas that are significantly darker or lighter than the rest of the scene.

need to freeze subject movement will place a lower limit on the shutter speed you can use. To preserve maximum detail, you should always use the smallest aperture that conditions permit. As a standard item of equipment, you should carry with you a sturdy tripod in case the resulting shutter speed is so slow that you cannot hand-hold the camera without incurring motion blur.

Hyperfocal distance. Many nature photographs require that both distant objects and close objects simultaneously appear in sharp focus. Logically, it would seem that in order to have distant objects appear in focus, you must focus your lens at "infinity." In fact, a lens can be focused at a point short of "infinity" without causing distant objects to lose sharpness. A lens set to the so-called *hyperfocal distance* causes the depth of field to extend much nearer to the camera than occurs when the lens is focused on "infinity," while still rendering distant objects in sharp focus.

Lenses that have depth-of-field indicator lines marked can be easily set to the hyperfocal distance. The procedure is to focus the lens so that one or the other of the depth-of-field indicator lines on the focusing ring lies directly over the "infinity" setting. (The depth-of-field marking you use must correspond to the *f*-stop at which you have the lens set. Each time you change the *f*-stop, you must refocus the lens to a different hyperfocal distance.) Any time you want to include both distant

As long as lighting intensities are reasonably close together, areas in direct sunlight can be included in a photograph along with areas in shadow.

Because the left side of this canyon was uniform in color, the difference between areas in sunlight and shadow was not large enough to create a contrast problem. The only area where the contrast in this scene exceeds the ability of the film to record detail is within the mist at the bottom of the waterfall, where the extreme whiteness is perfectly acceptable.

In the photograph on the opposite page, the problem resulted because the area in shadow was naturally dark, whereas the area in sunlight was naturally light.

Only through experience will you develop an eye for unworkable contrast differences. By making a conscious effort to develop a critical eye, however, you can speed the process immensely.

Too little contrast can be almost as bad as too much contrast. Taken at a different time of day, this photograph could have been quite substantially improved. Both foreground and background are interesting, detail is excellent throughout, and the overall treatment conveys some of the grandeur of the Painted Desert. However, the lack of contrast caused by shooting in a midday sun gives the photograph a dull, gray appearance which completely undermines its other attributes.

In the photograph at left, which was shot early in the morning, the sun's lower angle generated enough contrast to define the elements of the scene clearly and interestingly. Had this photograph been taken at midday, it too would have suffered from an insufficient amount of contrast.

and near objects in sharp detail, you should use the hyperfocal distance setting.

CONTRAST CONTROL

Serious nature photography is often undertaken on bright days and sometimes at high altitudes where a cloudless sky and strong sun can produce both brilliant highlights and dark shadows in the same scene. Because the eye will usually be able to detect detail simultaneously in both highlight and shadow areas even when the film being used will not be able to record detail in both, inadequate contrast control is a common problem in nature photographs.

Light meters give average readings and, because of the distances involved, ordinarily you will not find it possible to take separate readings of highlights and shadows. Therefore, you must learn to recognize extreme contrast conditions by eye, and take steps to prevent your photographs from containing large shadow or highlight areas devoid of detail.

With black-and-white film you can sometimes control contrast by darkroom manipulations. Another solution is to crop your photograph carefully so that it does not include areas that are illuminated by widely divergent intensities of light. You might also photograph when the sun is behind a cloud, or at a time of day when the particular area receives a more even light. (Be careful, however, that the scene does not lose so much contrast that it appears dull.)

In photographs taken of subjects closer than about ten feet (3m) from the camera, too much light may cause the subject—a flower, for example—to acquire a greater range of contrasts than the film can record or to be lost against the mottled pattern the sun makes on the ground. Shooting under an overcast sky or when the sun moves behind a cloud will usually solve this problem.

Similarly, an overcast sky or a temporary cloud cover is usually necessary for photographing within a woods. In bright sunlight, the mottled appearance of light passing through tree branches is unattractive and creates too much contrast for film to record, whereas under a more even light the problem disappears.

YOUR PROJECT

Photograph both a panoramic scene and a close-up nature scene using fine-grain film and a tripod. In each situation, take the same photograph using three different lenses (if you have them): a normal lens, a slight wide-angle lens, and a full wide-angle lens. Be sure to use the smallest lens apertures conditions permit.

In each image include both foreground and distant elements. Through each lens, expose first with the lens focused on infinity, then set the lens to the hyperfocal distance appropriate for the aperture that you have set. Also, look for and photograph a variety of scenes in which different contrast conditions are present.

For the closeup in the woods, stand no more than ten feet away from your subject (which could be a fallen log, autumn leaves, or a patch of clover, for example). If possible, make some exposures both when a particular scene is bathed in direct sunlight and when the sun has passed behind a cloud.

Deep within a woods, light filtering through tree branches becomes mottled, producing contrast extremes which film cannot record. Under an overcast sky, however, contrast is reduced sufficiently to retain needed detail.

The fine detail evident throughout this photograph results from a combination of shooting with Plus-X film in the low-contrast light of a cloudy day and attaining the extreme depth of field produced by stopping down a 35mm lens as far as it can go. The exposure time these conditions required was a full second. Camera motion was eliminated by using a tripod.

Evaluate your results for detail and contrast. Study the effect on depth of field of lens choice and of focusing at the hyperfocal distance. Notice the effect on the foreground of using the different lenses, and try to make mental connections between the light present in a scene as you perceived it and as the film recorded it.

A SAMPLE PROJECT

In this sample project some of the problems as well as some of the potentials of nature photography are evident. All of these photographs were taken in national parks, but any scenic area will suffice to illustrate the principles this project is meant to convey.

One characteristic that frequently occurs in good nature photographs is a foreground which is not only shown in clear detail but is also interesting in its own right. For example, notice the role played by the foreground log in the photograph of the mountain lake. The log's weathered texture is readily apparent, and without the log the foreground would be visually rather dull. Moreover, the log serves an important compositional function by directing the eye sequentially from the foreground toward the rock on the left, across the lake, to the mountains in the background.

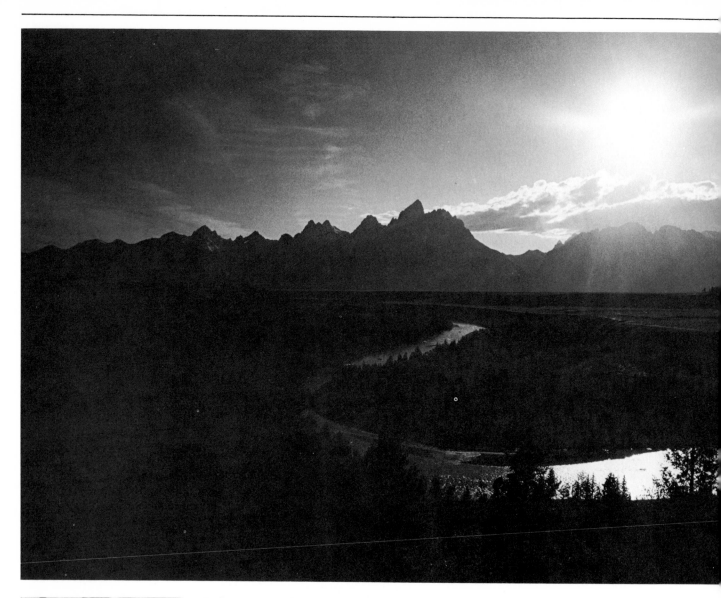

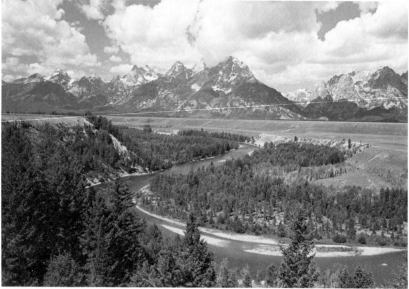

Including the sun in a photograph shifts the exposure value of a scene so that everything except the sun or its reflection is thrown into silhouette. The result often is a substantial increase in the dramatic impact of a scene.

At left a late morning sun shining from behind the camera produces a flat light and a dull photograph in which the main subject, Elbow Bend in the Snake River, is almost lost.

The same scene shot into the sun a few hours later provides a vastly superior photograph (above). At the exposure value necessary to photograph the sun and its reflection in the river, the mountains have become silhouettes and the river is now the focal point of the photograph.

BRILLIANT SUN

One of the most hallowed rules of photography is never to shoot with a bright sun in the frame of a photograph, yet situations exist when shooting into a bright sun can make an otherwise dull subject dramatic. However, some special precautions and techniques are required to control exposure.

WHAT YOU NEED TO KNOW

METERING

Taking a meter reading of the sun yields results that are difficult to interpret. Because the sun is so bright, a light meter—be it hand-held or the through-the-lens type—will give exposure figures that will sharply restrict the amount of light entering the lens. Any exposure made at these settings will invariably result in everything in the frame except the sun (or direct reflections of the sun) falling into darkness. As a result, the technique emphasizes the outline of objects rather than their form.

In a sense, there is no such thing as a "correct" exposure when shooting into a hot sun. The best exposure is the one that produces a pleasing balance between the brightness of the sun and the degree of darkness.

BRACKETING

Since you will find it nearly impossible to determine in advance exactly how a scene will look on film, you will most likely obtain a usable photograph by "bracketing" your shots.

Bracketing refers to taking additional photographs of a subject at different exposure values. In most circumstances, bracketing involves making at least one overexposed frame and at least one underexposed frame in addition to the frame taken at the exposure dictated by a light meter. However, when the sun is in the frame, you can be certain that you will not want the photograph any darker than it already is, so all of your brackets should be on the side of overexposure. For example, if the meter indicates a "correct" exposure of 1/125 second at f/16, you would also expose frames at f/11, f/8, and f/5.6 for 1/125 sec.

The extent to which you need to bracket changes depending on the lens you are using. The shorter the focal length of a lens, the smaller the sun appears in the frame and therefore the smaller the sun's influence on the meter reading.

Bracketing helps you control the amount of detail present in the final print. The sun will always be a bright mass devoid of detail but, as you lighten the exposure, more and more detail will appear in the rest of the photograph. At some degree of "overexposure" you will find the desired degree of detail.

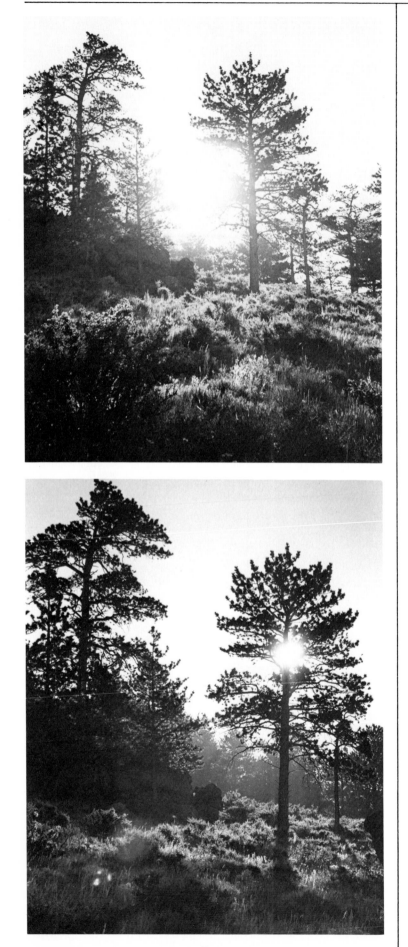

As a scene containing the sun is lightened so that foreground detail is revealed, the ball of the sun and its surrounding area appear progressively larger in the frame (top photo). By partially obscuring the sun behind an object within the scene (bottom photo), you can strike a balance between the amount of foreground detail you want and the size of the sun.

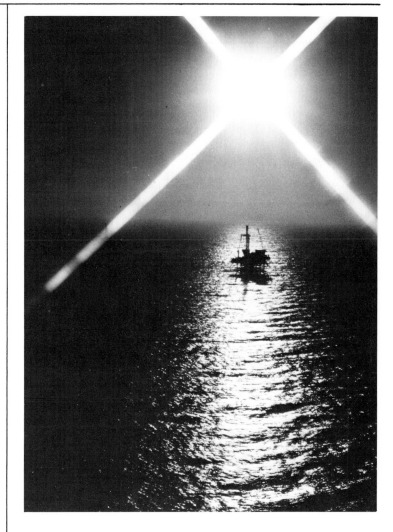

Often, a photograph that includes the sun but which has relatively little inherent interest can be improved by using a star filter on the lens.

The size of the star formed by a star filter is directly proportional to the intensity of the light source in a scene. As a result, the star formed by the sun can be quite prominent. The star effect can liven up areas that have fallen into complete silhouette. However, you must be careful to make certain that the star works well compositionally with the scene and does not interfere with the main subject.

LENS FLARE

When direct light enters a lens, stray light often bounces around within the lens and is deposited on the film in what is called "lens flare." Flare takes two forms: polygons of light, and a general haziness over the film frame.

Modern lenses are coated to minimize the effects of lens flare, but flare can nonetheless occur, especially when a lens filter is present. Zoom lenses are particularly susceptible to the effects of flare and commonly produce multiple images of the light source. Any time you are shooting into the sun, you must assume that some flare will be produced.

Most people today are accustomed to seeing flare in photographs and accept it. Your goal must be to make certain that any flare that does exist is not located where it will detract from the photograph. To reduce the effects of flare you can close the aperture a stop or two.

DILUTING THE SUN'S INTENSITY

In some circumstances, obtaining a pleasing balance between the detail present in a scene and the brightness of the sun is impossible unless the sun's intensity is somehow lessened.

One way to dilute the sun's intensity is to position yourself so that the sun is partially blocked by an object within the scene. To insure that you end up with a usable frame, take a series of exposures with the sun revealed to varying degrees, and be sure to bracket carefully.

YOUR PROJECT

Photograph an object with a bright sun in the frame. The object could be a person, a statue, a tree, a building, or anything else that has a distinct outline. Be sure that you are not taking your photographs at sunrise or sunset, and shoot in both black and white and color.

Take at least one series of photographs in which the entire sun is exposed. Bracket each scene. Take another series of the same or a different scene. This time obscure the sun behind an object. Vary the amount of the sun showing. Bracket your shots.

Use color filters for some of your color photographs and, if you own one, a star filter.

When printing your black-and-white negatives, make one print from the frame exposed at the *f*-stop indicated by the meter. Make another print from one of the bracketed frames in which foreground detail is more apparent. Burn in the sky so that it resembles the sky in the first print.

Study your results to determine the relationship between the visual appearance of the sun, indicated meter readings, and the appearance of the scene in the resulting photograph. Notice especially the effects of bracketing.

A SAMPLE PROJECT

The photographs shown on these pages illustrate some of the effects shooting into the sun can produce. Remember, however, that results are quite unpredictable and that the more film you shoot, the more likely you will be to obtain usable results.

Notice that in some of the photographs filters have been employed to lessen the starkness that shooting into the sun produces.

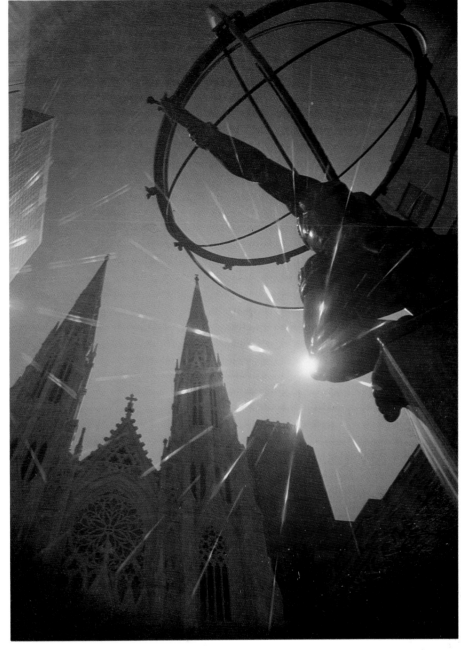

Shooting into the sun results in essentially a black-and-white image, even with color film. To reintroduce some color, you can add a color filter to your lens. Filters designed for use with color film are available commercially. However, the same filters used in black-and-white photography will also work. Both these views of Rockefeller Center in New York City benefit from the use of filters. In the lower photograph a rainbow filter helps enliven the scene, but the addition of a red filter in the upper photograph is even more dramatic.

Notice that the midday sun present in these photographs had to be toned down by positioning it behind the statue's knee. The sun's reflection in the building on the left side of the images also produces a star effect.

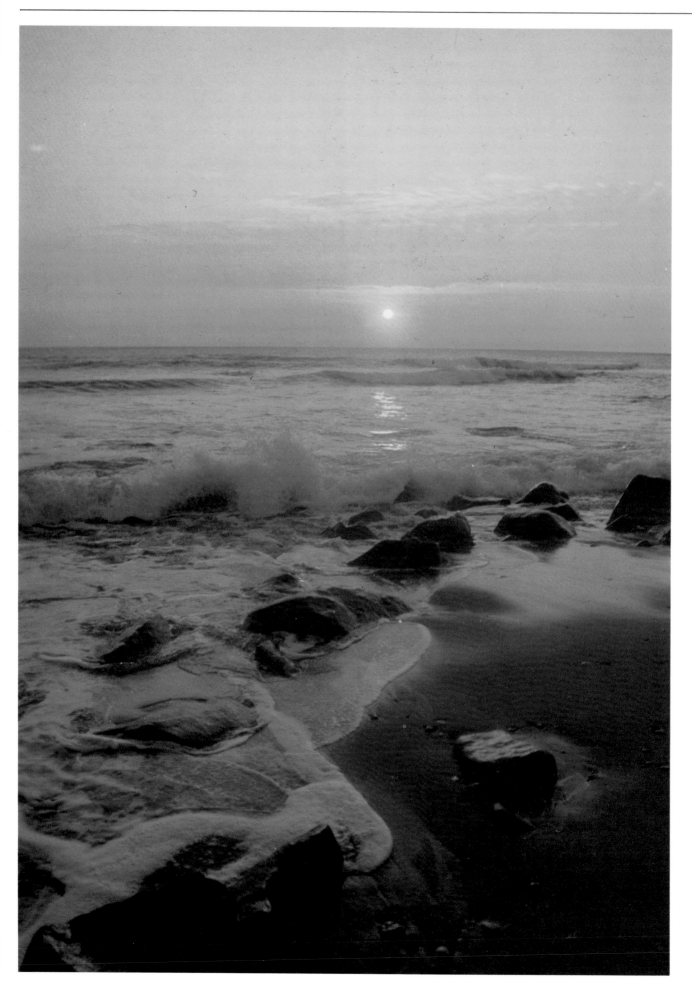

Taping a variable-contrast filter to a lens can shift the color of sunset. Because these filters are made in a range of intensities, you can use them to control the extent to which color is shifted. Light intensities in this photograph are nearly perfect. The sun is slightly washed out due to overexposure, but because the wide-angle lens used results in the sun being small in the frame, the overexposure is barely noticeable. Had the exposure of the sun been exactly correct, detail would have been lost in the foreground, resulting in an inferior photograph.

When the sun's intensity has not been sufficiently diminished by clouds or haze, a correct exposure of the sun results in the rest of the frame appearing grossly underexposed (far right). Although in both of the photographs at right the sun is too intense, in the near photograph reflections of the sun off the water add just enough foreground detail to produce an acceptable image.
Notice that in this underexposed condition the primary appeal of a sunset—a beautiful sky—is completely lacking.

19 SUNSETS

Almost any photograph can benefit from the inclusion of a sunset, even if the sunset is acting merely as a backdrop for the main subject. Although sunsets require carefully controlled exposures, learning to take consistently good photographs containing the sun is not an especially difficult task.

WHAT YOU NEED TO KNOW

RECOGNIZING PHOTOGRAPHABLE SUNSETS

Your purpose in photographing a sunset is not simply to include the ball of the sun, but to incorporate also the exciting colors that sunsets can produce. Because those colors result from the presence of clouds and atmospheric haze from moisture or even air pollution, the setting sun on a clear day holds comparatively little photographic interest. (For photographing such a sunset, you could use some of the techniques suggested in Project 18.)

Aside from adding color to a sunset, clouds and haze perform a critical function; they diminish the sun's intensity. If the sun is too bright, no matter how pretty the sunset colors are, they will be completely underexposed in the photo unless the sun is so overexposed that it becomes a large, colorless mass. In short, the important characteristic of a good sunset is a proper balance between the brightness of the sun and the brightness of the colors it produces.

As a rough guide to whether the sun is sufficiently weak to photograph, glance at it *once,* briefly. If it is impossible to look directly at the sun even for an instant, or if while looking you are forced to squint, the sun is probably too strong. (Of course, you should *never* look directly at the sun for more than a fraction of

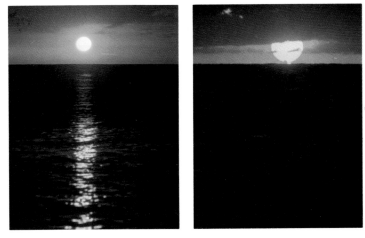

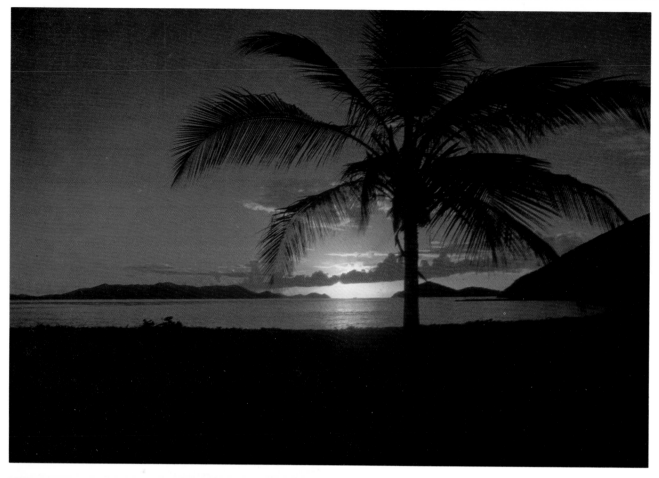

Because a sunset usually offers only about fifteen minutes of shooting time, the decisions you make while shooting a sunset must be executed quickly and can have a marked influence on the effect the sunset produces.

These two photographs were shot within seconds of each other. Notice the difference produced by switching from a 20mm lens (lower photo) to a 200mm lens, and of using a red filter (upper photo) instead of a magenta filter (lower photo). Each time you double the focal length of the lens you are using, you double the size of the sun in the frame. To fill the frame with the sun, you need a lens with a focal length between 800mm and 1000mm with a 35mm camera.

a second, no matter how weak the sun may be.) In many instances, merely the presence of brilliant colors in the sky is an accurate indication that the sun is weak enough to photograph.

CONTROLLING THE SUN'S INTENSITY

Although you have no direct control over the intensity of the sun, some methods do exist that have the same effect.

On a clear day, you can wait until the sun has dropped partially or completely below the horizon. As more and more of the sun's ball becomes obscured, the likelihood of establishing a proper exposure balance increases. Even after the sun itself has disappeared, often enough color lingers in the sky to form the basis for a beautiful photograph.

Sometimes, even though the sky is clear, a few random clouds will be present, especially near the horizon. By being ready to take a photograph, but being patient enough to wait until the sun passes partially or completely behind a cloud, the few moments during which the sun's intensity is lessened will provide enough time for you to obtain your shot.

Your choice of lens is also important. The larger the proportionate size of the sun in the frame of a photograph, the greater the effect of its brilliance on exposure. A sun that is overpowering when photographed through a telephoto lens may pose no problem at all when you use a wide-angle lens.

FOREGROUND DETAIL

The weaker the sun, the greater the amount of detail that will appear in the foreground of a photograph. Unless lit from the front by supplementary light, foreground objects will partially fall into silhouette. (Usually some detail will still be present, especially along the ground or on the surface of any water present in the scene.) The extent of that detail depends on the relative intensities of the sun and foreground, and on exposure.

Since foreground objects will be rendered in full or partial silhouette, you should make certain that the outline of objects is recognizable. For example, people should be shown in profile because in full view their outlines are less interesting.

ENHANCING COLOR

Many sunsets can stand on their own, but sometimes you can improve a sunset through the use of color filters. Orange, red, and magenta filters are most useful.

Various types of filters will work: orange and red black-and-white filters; filters specifically designed for color photography; the color-compensating filters used for processing color prints; and even the variable-contrast filters used in black-and-white printing. Color-compensating filters and variable-contrast filters are especially handy since they permit you to control the intensity of the color you add to a scene.

METERING

Determining exposure is the most difficult aspect of photographing sunsets. Although you can always shoot a scene at a variety of exposure values in the hope that one will be correct, color film is expensive, so the effort to determine the correct exposure with a light meter is worthwhile to preclude the need for extensive bracketing. Moreover, conditions sometimes change rapidly as the sun sets, allowing scant time for bracketing.

Metering a sunset accurately requires that you make a cru-

cial decision about which direction to point the meter. At one extreme—in a weak sun, with a wide-angle lens, and for no foreground detail—you can point the meter directly at the sun and obtain an accurate reading. (With a "center-weighted" through-the-lens meter, you should locate the sun in one corner of the viewfinder to take the reading.) At the opposite extreme—in a strong sun, with a telephoto lens, and for substantial detail—you must point your meter at a 45-degree angle above or to the side of the sun. Under other combinations of conditions, you must decide at which intermediate position to point the meter.

YOUR PROJECT

Set up a systematic experiment to teach yourself to recognize where the light meter should be aimed under various conditions. For each lens, and under a variety of sun intensities, expose a frame at the setting indicated when your meter is pointed toward the sun, and at 15, 30, and 45 degrees away from the sun. Try to select scenes with foreground objects suitable for silhouetting. To be able to learn from your results, you must maintain written records for each frame you expose.

Evaluate your results in terms of the relationship between your perception of the sun's intensity, the size of the sun in the frame, the angle at which you took the light reading, and the amount of foreground detail present in the final photograph.

When you think you have a feel for photographing sunsets, experiment with the use of color filters.

A SAMPLE PROJECT

The photographs shown here all depended upon preparation. Well in advance of sundown, locations to shoot from were identified, and interesting foreground elements were selected. In addition, the necessary filters were organized so that they would be easily accessible during what often turn out to be a few hurried moments while conditions are exactly right for photographing.

As you compare the photographs shown on these pages, notice the importance of foreground detail. In those photographs with strong, graphic silhouettes, foreground detail is not necessary. In the other photograph, however, foreground detail adds interest to areas which would otherwise be large, black masses.

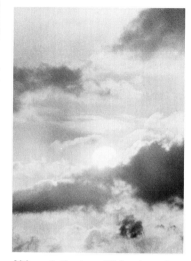

Although the beautiful colors that can be produced by sunsets are lost on black-and-white film, sunsets can be attractively photographed in black and white if the sun's light is being reflected by interesting cloud patterns. The same techniques apply for determining exposure with black-and-white film as with color.

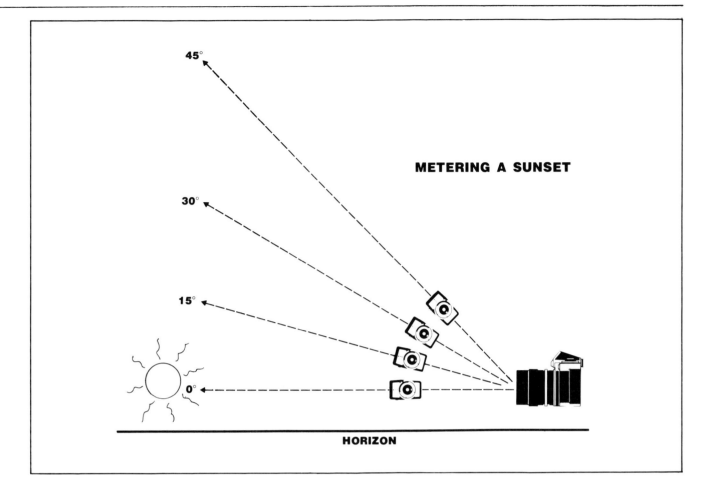

METERING A SUNSET

45°

30°

15°

0°

HORIZON

Unless you are using a very wide-angle lens or the sun's intensity is greatly diminished, you should not let any of the sun's direct rays influence your light meter when taking an exposure reading. Instead, you should point your meter as much as 45 degrees above or to the side of the sun. The stronger the sun, the farther away the meter should be when you take your reading. If you have chosen the angle correctly, and if the sun's intensity is sufficiently diminished by clouds or haze, the exposure settings indicated by your meter will result in a properly exposed sun and brilliant color in the surrounding clouds.

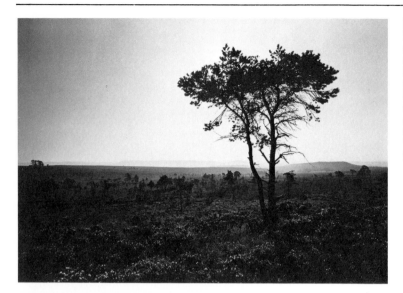

Merely changing the point of view on the tree by moving to the opposite side and shooting into the sun helped make a statement. No longer is it simply a tree in a field, it is now a solitary tree standing in the midst of a flat, barren landscape. Moreover, interest is increased by the strong contrast between the tree and the sky, which results from the tree falling into silhouette. The photograph seems to say, "Here is a tree whose lot is to wrench life from a barren expanse."

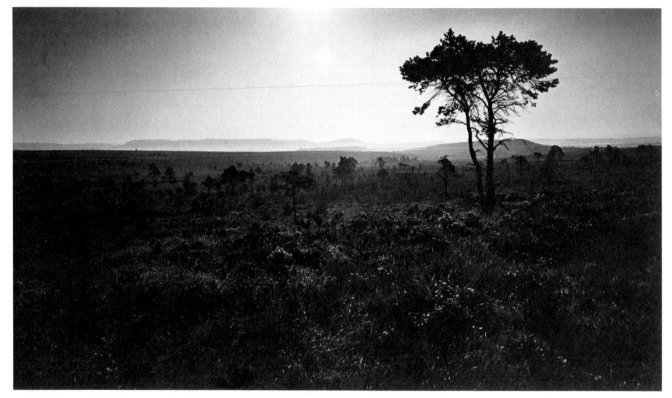

Remaining in almost the same location but switching from a 35mm lens to a 20mm lens further enhanced the feeling that characterizes the upper photograph. The shorter focal length creates a greater feeling of loneliness because the tree becomes even smaller in the frame and therefore appears more isolated. However, even with its smaller size the tree still commands as much attention as in the photograph on the previous page because of the tree's greater contrast with the sky.

In the upper photograph the statement was primarily intellectual in that the feeling of loneliness stemmed from the realization that the mountains in the background must be far away. In the above photograph, however, the same basic statement relies more on the feeling produced by the wide-angle lens than on the intellectual interpretation of distance clues.
Notice that this photograph was cropped to emphasize the horizontal dimension to further support the feeling of loneliness.

20 | INVESTIGATING A SUBJECT

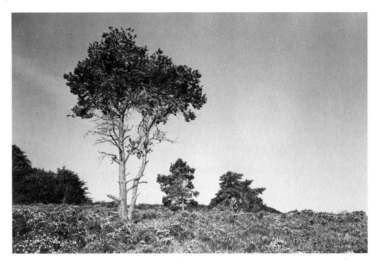

This photograph illustrates what can happen when no attempt is made to make a statement. Although the photograph is technically correct and compositionally balanced, the treatment can best be described as uninspired. We know the tree exists, and we can see that it is living in a field, but the photograph tells us little else.

One of the characteristics that separate skilled photographers from novices is the ability to make a statement in a photograph. This skill results in a photograph that is far more interesting because it has a reason for existing beyond merely proving that the subject exists.

Almost invariably, photographic statements result from a conscious effort to form an opinion about a subject and then express that opinion. These opinions result from an active questioning process that should be initiated even before the first exposure is made. A typical series of questions would include questions like: "What is it about this subject that appeals to me? Do I like its shape? its color? its texture? Is there something special about where this subject is located that can be shown in my photograph? What interests me most about this subject? Which angle of view would best help me capture that interesting aspect in my photograph? which lens?" The list of questions is almost endless and, of course, varies with the subject and existing conditions. But the process of asking and answering the questions is fundamental to successful photography.

WHAT YOU NEED TO KNOW

EXPLORING WITH YOUR CAMERA

The pleasure of small-format photography stems in large measure from the flexibility possible with easily portable, highly versatile equipment. Because small-format cameras, specifically those utilizing 35mm and 2 1/4-square films, are so maneuverable, they permit many exposures of a subject to be made quickly and easily. As a result, small-format photography facilitates the process of "exploring" a subject photographically and thereby encourages the formulation of clear photographic statements.

The concept of exploring with your camera rests upon the assumption that the first exposure you make of a subject may not be the best, and that a given subject can often be used to make more than a single statement.

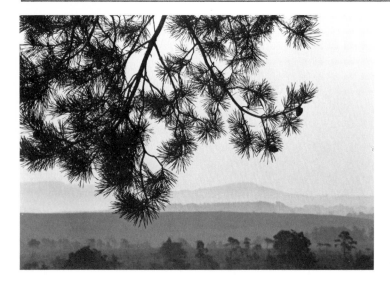

What a viewer thinks about your subject is determined by the details that you decide to emphasize. Moreover, by moving in to show detail, you tell a more succinct story in your photograph.
In this photograph, shooting from underneath the tree through a normal lens shifts the emphasis away from the feeling of loneliness to the concept that the tree is a living, growing entity. Here the statement might be: "Even in harsh conditions, this tree is thriving."

Exploring a subject means that you do not stop with the most convenient means of obtaining a photograph. Instead, you move around, viewing the subject from different positions and angles. You study the subject up close, from a distance, and from in between. You analyze the effects of different perspectives by changing lenses. You photograph with the light at your back as well as with the light in front of you. In short, you leave no aspect of the subject unexplored.

At the end of the exploration process, you will have obtained a variety of photographs taken from different perspectives and through different lenses, presenting a range of different statements about the subject. In all likelihood you will find one frame that is your favorite, and a few additional frames that are especially pleasing. Each of these will constitute a substantial improvement over the "snapshot" appearance of a photograph taken without much thought or effort and, collectively, the photographs will comprise a "documentary"—an indepth, photographic exploration of many facets of the subject's existence.

Considered alone, this photograph merely illustrates the texture of the tree's bark, but considered together with the other photographs it contributes to an understanding of the physical nature of the tree. Texture, such as that shown here, is best revealed by a strong sidelight.

YOUR PROJECT

Photograph a tree. A tree is relatively devoid of inherent interest yet, by using your camera to answer questions about the tree, you can learn to instill interest in an otherwise dull subject. Use at least two rolls of film, preferably black and white. Produce a series of five photographs telling the story of the tree and of the environment in which it lives. A viewer who studies the five photographs should be able to obtain a clear idea of what the tree looks like and where it lives. Include at least one abstract study of the tree, and use lenses of at least three different focal lengths.

For an advanced project, include a shot taken with a super-wide angle lens, a super-telephoto, or a macro lens.

A SAMPLE PROJECT

The tree selected here as the subject of the sample project is a scruffy pine located on a remote moor in the heart of England's Devon countryside. The photographs shown on these pages illustrate the documentary effect that results from a con-

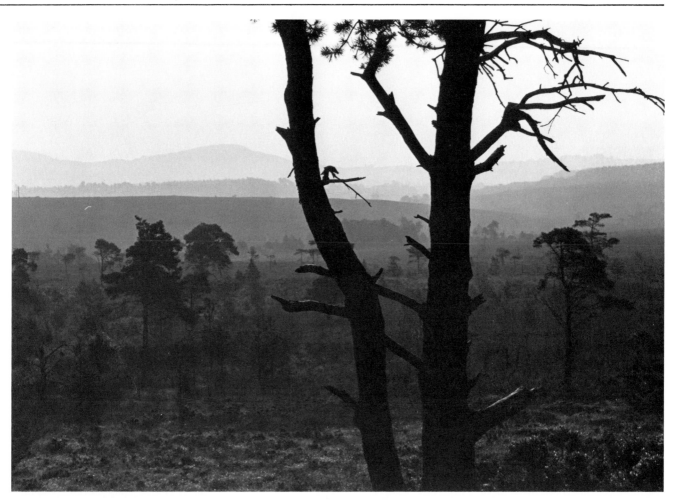

This photograph shifts attention only slightly downward from that shown in the photograph at the top of the opposite page, but the message is radically altered. In this instance the statement becomes something like: "In these harsh conditions, life is a constant struggle, and death will ultimately take its toll."

scientious effort to explore a subject photographically. If you view the photographs collectively, you will find that they tell a comprehensive story about one particular tree.

The photographs shown result directly from the answers to such questions as, "What are the characteristics of this particular tree? Is it thin or fat? short or tall? straight or curved? alive or dead? How can I best reveal its shape? Its condition?

"What makes this tree special or unique? How is it different from other trees in general and from nearby trees in particular?

"How can I relate this tree to its environment? Do I want the tree to dominate the photograph, to have equal weight with other elements, or to be subordinate to them?

"What abstract qualities does the tree have? What are its graphic characteristics? Does it as a whole or in part possess interesting shapes, patterns, or colors that I could bring out in my photographs?"

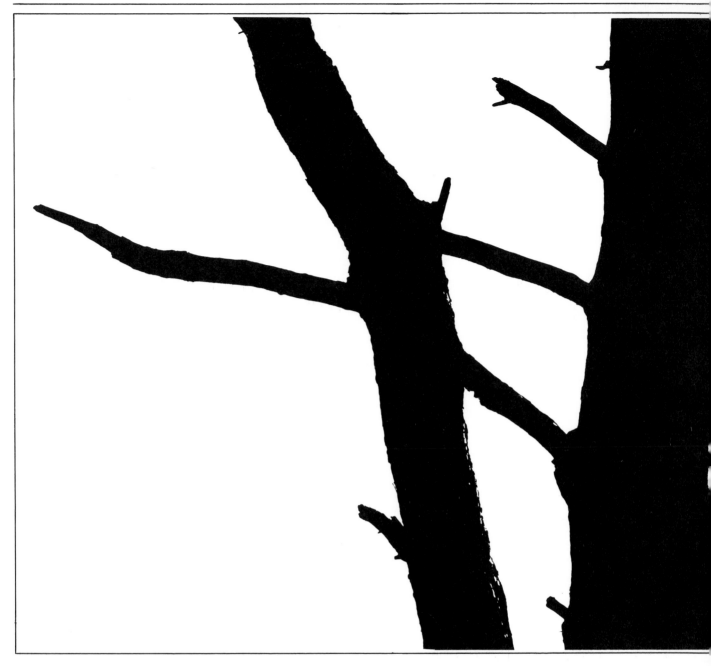

The way you use light can have a
profound effect on the statements
your photographs make.
Each of these photographs is of a
leafless section of the tree but, in
the upper photograph, shooting
directly against a bright sky
causes the figure of the tree to
fall into silhouette. (Printing the
image on high-contrast paper
further enhanced the effect.) As a
result, meaning results entirely
from the shape present, and not
at all from recognition that the
subject was a tree.
At left, however, enough light is
striking the portions of the
branches facing the camera to
clearly identify the object as
being part of a tree branch. Thus,
merely because enough light is
falling on the branch to define it,
the subject of the photograph
becomes identifiable and
therefore the abstract qualities of
the subject lose emphasis.

ABSTRACT COMPOSITIONS

The goal in most photographs is both to show the way an object looks and to use that object to make a visual statement. With abstract compositions, however, the meaning of a photograph is derived solely from the form and placement of light, shadow and, in the case of color photography, color. Indeed, the actual objects providing the forms in a purely abstract photograph are irrelevant and need not even be identifiable.

All photographs contain forms that have a compositional impact, but photographers frequently overlook that impact and concentrate only on the identifiable objects contained in a scene. By practicing the technique of visualizing the abstract compositional influences objects contribute, you will become skilled at exploiting their abstract qualities in any photograph you take.

WHAT YOU NEED TO KNOW

Because an object is "ordinary" does not mean that a photograph of the object must also be ordinary. Any object can be made interesting in a photograph if you identify shapes and forms within the object that are in and of themselves interesting, and then arrange and light the shapes and forms with imagination and skill.

IDENTIFYING ABSTRACT QUALITIES

Asking appropriate questions. Fundamental to making an abstract photograph is studying the object and asking yourself the right preliminary questions. Ask yourself, "What makes this object unique? What do I like about this object? What about this object can I use as the subject of my photograph?"

Isolating component forms. Identify the component forms of the object. Are they round, square, rectangular, oval, or straight? Ask yourself how you would isolate one or more of those forms and use it or them in a photograph. Try to identify the relationship between the component forms of an object and its function (e.g., sharp edges are related to cutting functions).

Using light imaginatively. View the object in a directional light, for example, in sunlight, or in the light from a single light bulb set off to one side. Do not be biased toward the type of light in which the object is commonly viewed. If possible, turn the object around in the light and study it from different and unusual angles. Watch the way the light plays on the form as it turns. Try to visualize how the interplay of light and shadow would look in two dimensions on a sheet of paper.

When a recognizable object is included in a photograph, some of the photograph's meaning derives from recognition of what the object is and what role the object plays in the world. An abstract photograph, however, relies only on shapes and form for meaning.
On the following pages, abstractions are shown using this pair of scissors. Before looking ahead, try to visualize how you might use this object or parts of it to create an abstract design. Start by analyzing the scissors into its component shapes, then imagine how you might arrange those shapes across a two-dimensional sheet of paper.

In a pure abstraction, the original object is completely unidentifiable. The photographs on these two pages show varying degrees of abstraction.

Above, the photograph is very abstract. If you did not already know that a scissors was the subject, you might be hard pressed to identify the object being photographed. At right, above, the photograph is less abstract because the shininess apparent in the handle suggests a quality of the material used to form the design. The darker reflections in the handle are there intentionally.

At left, the photograph is least abstract because the form of the scissors is clearly identifiable. However, if you ignore your knowledge of the subject, the abstract composition is balanced and effective. Notice that your eye is automatically drawn along the diagonal line and focuses irresistibly on the point. Compositionally, vertical and horizontal lines are less dynamic than diagonal lines.

In abstract compositions, the relationship between the format used and the shape of the arrangement of elements within the photograph is apparent. Notice in the photograph on the top of the previous page how the overall shape of the handles suggests a horizontal rectangle, so the photograph was composed with the camera held horizontally. In the photograph above, with the handles closed and with part of the scissors joint included in the frame, the composition now lends itself to a vertical format. At left, the overall shape of the scissors is again vertical, as is the format.

PHOTOGRAPHING THE OBJECT

The most effective ways to emphasize form are to photograph an object in silhouette, or to light the object against a black background.

To produce a silhouette, place the object in front of a white background. By throwing a strong light on the background but no light at all on the object, a silhouette will be formed. If the object is shiny, you may have to surround it with black cloth. (See Project 15.)

To light an object against a black background, use velveteen, if available, in order to eliminate all background light. Be sure that the edges of objects are lit in such a manner that they stand out against the black background. Often, you can position white pieces of cardboard where they will throw light onto edges.

YOUR PROJECT

Expose as much film as necessary to produce three abstract black-and-white photographs of a commonplace object. In the first photograph, use a silhouette technique to show an abstract form. In the second photograph, reveal form by using lighting that reveals some surface detail. In the third photograph, illustrate abstractly some quality of the object you are photographing. For example, if you are photographing a cup, suggest in the photograph its function in containing liquids. If you are photographing a car, suggest its shininess or its dirtiness or some other pertinent aspect of the car.

A SAMPLE PROJECT

The photographs here are of a small object, so a macrolens was used to be able to focus close enough to show only portions of the object. If you do not have a macro lens or close-up rings, you can photograph a larger object such as a bicycle, a fence, or a car with a standard lens.

This is a difficult project. It is hard to conceptualize and takes time to execute. The setups required a substantial amount of experimentation, but not very much equipment. You could obtain perfectly good results by lighting your scene with a table lamp and using reflectors as needed.

This composition is intentionally designed to emphasize a quality of the scissors—its pointiness. The extremely bright reflection in the left blade was meant to focus attention on that blade and contrast it with the less severe shape of the other blade. Standing the blade on its point further accentuates the pointiness.

The position of reflectors was critical. One large reflector had to be located where its reflection would appear in the far blade, and others had to be located where they would delineate the entire edge of the near blade.

Notice that although the background paper is actually white, in the photograph the paper appears gray (and black where there is shadow). The reflection in the left blade is so bright that in order to tone it down, the entire photograph had to be underexposed.

You can use shadows to define an object's shape in a photograph.
Looking down on the glasses in the photograph above, a viewer cannot discern the exact shapes of the glass and bottle. By shining a bright, highly directional light on the scene, however, clear shadows are formed which delineate the objects' forms distinctly. Had the objects been photographed from the side, the emphasis would have been more on the fact that they are made of glass than on their shapes. Aside from providing information, the shadows play a compositional role. Alone, the glasses throw the compositional weight of the photograph toward one side. The shadows counteract that weight and balance the photograph compositionally. In addition, because of the irresistible temptation to compare the appearance of the glass and bottle with the shapes of their shadows, the presence of the shadows adds viewer involvement and heightens the inherent interest of the photograph.

Photography may be "writing with light," but pure light is meaningless unless there is shadow (see Project 1). Shadow can do more than simply give objects definition, however. Shadow can also serve as a photographic subject in its own right and can play an important informational or compositional role within a photograph.

The fascination people have with shadows is similar to that of watching moving clouds and trying to read into them a recognizable form. In the real world shadows have no substance other than to signify that an object is blocking light. On film, shadows have as much substance as any other element, and sometimes more. In photography, shadows are significant.

As a photographer, you should look beyond the material objects in a scene and become sensitive to using intellectual clues to give meaning to your photographs and to improve their aesthetic appeal. Actively looking for shadows to photograph is one way to help you hone your general ability to recognize and exploit visual clues that give your photographs meaning.

WHAT YOU NEED TO KNOW

ADDING MYSTERY

In motion pictures, shadows have long been used to evoke a feeling of suspense and mystery. For example, many a movie has relied on the image of a hand's shadow moving across a door to suggest tension and foreboding. The shadow's feeling is ominous because the viewer does not know exactly what to expect.

A photographer can use shadows to create a similar (though not necessarily ominous) sense of mystery. By not revealing everything, a shadow stimulates the mind of the viewer. Furthermore, the process of interpreting the shadow increases viewer involvement in a photograph and makes it more intriguing.

EMPHASIZING SHADOWS

A shadow is intangible, but within a photograph, a shadow has just as much compositional significance as any other element. Indeed, if the shadow is strong enough, it can be the photograph's most important element.

Since the camera is not as selective as the human mind, the objects in a scene that attract immediate attention may not make the same impression in a photograph. Therefore, you must be careful to make certain that if a shadow is the main subject of your photograph, your emphasis is clearly on the shadow.

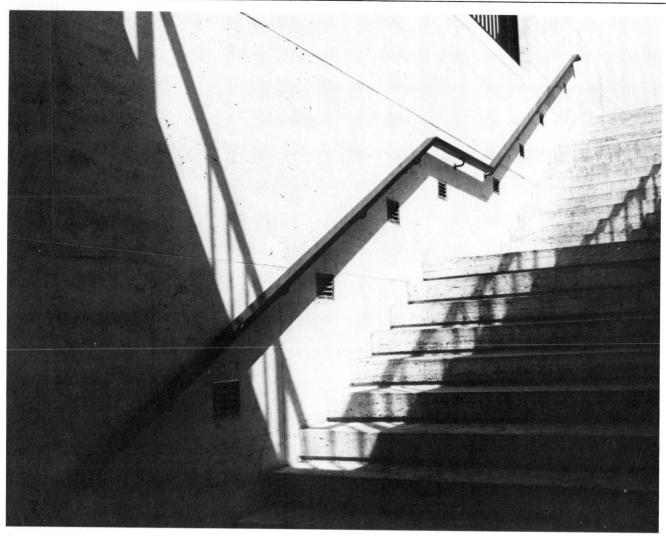

By constantly observing the effects of shadows, you will find that interesting abstract patterns are often formed in the presence of strong, directional light. The interest of this photograph lies primarily in an abstract composition based upon a "v" shape repeated again and again throughout the photograph. This photograph's meaning has nothing to do with knowing what the literal subject was. Printing this photograph on high-contrast paper would have eliminated all gray tones and made the scene completely unrecognizable, but would not have detracted from the photograph.

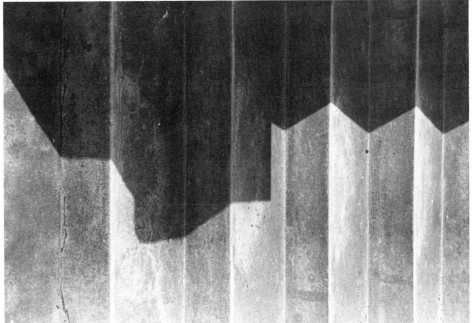

Not only can the shadow of an object define its shape, but an object can also be defined by the shadows falling upon it. The photographs on this page are all of the same stairway. Immediately above, without the presence of shadows, a closeup of a set of stairs is essentially unrecognizable. Sometimes monotone compositions can be interesting, but in this case the gray tones are dull and the photograph has no impact. Waiting until later in the day and pulling the camera back far enough to include more information about the stairway does not solve the problem in the upper left photo. Although the presence of a shadow adds a little interest to the scene, and although the setting of the photograph is clearly recognizable, the scene itself is essentially mundane.
In the photograph at right, above, moving in close and photographing only the steps, but this time with a shadow falling across them, produces a much more interesting photograph. The shadow provides enough information to define the steps, and at the same time the juxtaposition of light and shadow forms an interesting compositional pattern.

Contrast. One way to guarantee that the role of the shadow as subject is apparent to a viewer is to make the shadow contrast strongly with its surroundings by using a strong, directional light and by having the shadow fall on a light-colored surface. If you do your own darkroom processing, you can enhance the dramatic effect by printing on high-contrast paper.

Cropping. A photograph should make a strong visual statement instantly. Indeed, the more succinct and unequivocal the statement, the better the photograph. As a general rule in photography, you are most likely to achieve a clear statement if you crop a scene tightly.

Toward this end, rather than starting out far from your subject and moving in if the scene in the viewfinder seems too cluttered, move in close to your subject at once. From a vantage point near your subject, study the scene in the viewfinder. Then, if you feel you need to include additional elements in the scene, move slowly farther away, always keeping in mind that the goal is to make your statement using as few elements as you can.

Tight cropping enables you to direct primary attention onto the shadow when it is the main subject of your photograph. In some instances, an effective technique is actually to crop out the object generating the shadow entirely.

COMPOSITION

The shape of a shadow can play the same psychological roles discussed in Project 1; a shadow with curving lines seems graceful, one with hard, angular lines seems dynamic. In addition, large blocks of shadow seem heavy or lethargic. As you compose a photograph, you must be careful to position all elements, shadows included, in such a manner that the frame has a balanced look.

YOUR PROJECT

For the first part of this project, take a photograph that is a complete abstraction, in which light and shadow have no meaning except as shapes. Look for interesting patterns to photograph.

For the second part, take a photograph in which the shadow cast by an object defines the object. Without the presence of the shadow, the object should not be easily identifiable.

A SAMPLE PROJECT

The most striking feature of the sample photographs is the role shadows can play in defining the meaning of a photograph and making it interesting. In the case of the glassware as well as the stairs, without the presence of shadows the photographs are uninteresting.

For these photographs, the exposure was determined by first reading the light area, then the dark area, then making the exposure at an intermediate setting. As a precaution, the exposures were bracketed.

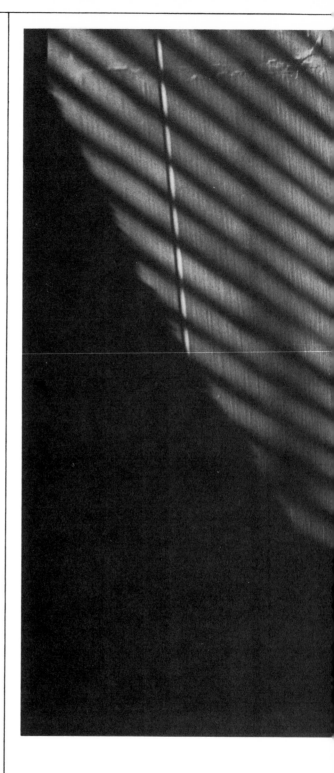

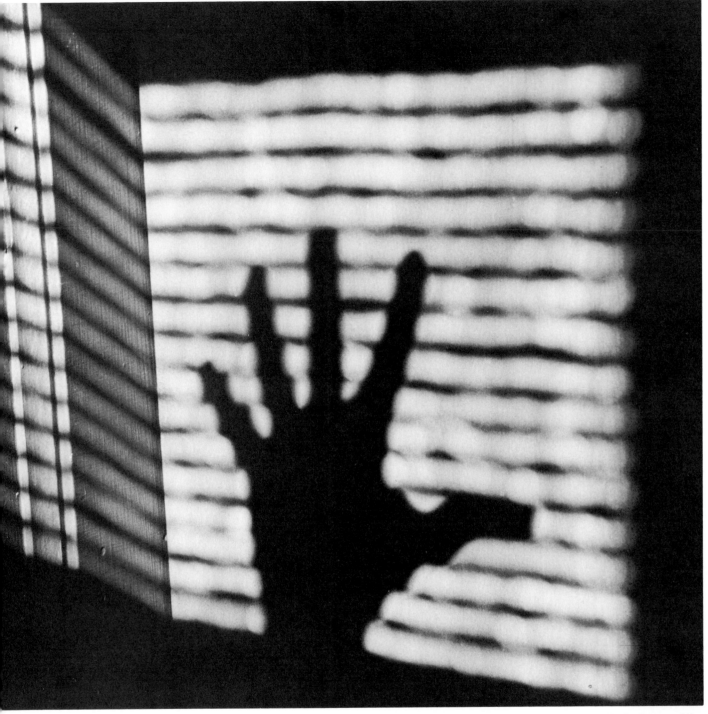

Part of the appeal of shadows is the sense of mystery they convey.
In this photograph, the shadow of the hand invites questions. Is the hand held up in terror, in supplication? Why is the hand held up at all?
In the process of attempting to clarify the meaning of the photograph, a viewer's mind interacts with the image of the shadow and becomes involved in the photograph at more than a cursory level.
Not all shadows are as mysterious as this one, but almost invariably when a strong shadow is present in a photograph, a viewer attempts to relate the shadow to its source.

Portraits taken outdoors in sunlight can suffer from the presence of dark shadows unless enough fill light is added to "soften" the shadows so that they show detail.

In the photograph at upper left, the sunlight originates from behind the woman and is not falling directly on her face. Reflectors positioned around and below her are illuminating those portions of her head and shoulders facing the reflectors (lower photo).

The reflectors reduce the harshness of the sunlight. Had the woman been facing the sun and had reflectors not been used, shadows would have been very noticeable beneath her brows, nose, cheeks, and chin and she probably would have been forced to squint.

OUTDOOR PORTRAITS

One of the most useful skills a photographer can possess is the ability to use reflectors to control the relative intensities of light and shadow in a photograph. Although such control can be useful in almost any photographic situation, skill in using reflectors can usually be learned best in the course of taking a portrait outdoors where the light, without the use of reflectors, would be completely beyond control.

WHAT YOU NEED TO KNOW

PRODUCING A "SMOOTH" LIGHT

When sunlight falls on a person's face from an angle, shadows will form under the brows, nose, and chin. The higher the sun and clearer the sky, the more intense the shadows formed.

The presence of shadows is not inherently bad. Indeed, some shadows are desirable in a portrait for defining a person's features and lending the face character. However, there is no set rule for determining the proper intensity of shadows in a portrait. Although in some circumstances a photographer will intentionally make a creative decision to include harsh shadows, in general, shadows that are so dark that detail is lost are a liability. Since direct sunlight invariably produces shadows that fall beyond a film's ability to hold detail, some means is therefore necessary for introducing some light into the shadows to produce a "smoother" light, a light which does not generate harsh shadows.

One of the most effective methods for "filling" shadows is to bounce light into them by using reflectors. The goal in using reflectors is to add enough light to reveal detail in the shadows without making the overall light falling on the subject so smooth that the shadows disappear altogether.

Light ratios. The difference between the brightness of any two tones in a photograph is measured in terms of light ratios. In portraits, the concept is most commonly applied to the difference between the brightness of the subject's face and the darkness of shadows.

Light ratios are determined by means of light meter readings. If the meter reading indicated for the illuminated portion of a person's face is $f/8$ and of the shadows is $f/2.0$, then the difference in light intensities is four f-stops (the number of changes to make in f-stops in the process of changing lens apertures from $f/2.0$ to $f/8$). Technically, a light ratio should be expressed in terms of comparative light intensities (2:1, 3:1, 4:1, etc.), but in common practice nobody actually makes the con-

version and a given light ratio will be referred to as consisting of a certain number of f-stops.

In a portrait, the recommended light ratio depends on the film being used. For black-and-white film, the ratio should be between one and two f-stops. For color film, the difference should be no more than one f-stop. (With color film, a completely smooth light—one in which no shadows are formed—can be acceptable when color differences provide the definition of features provided by shadows in black-and-white photographs.)

Determining light ratios with a meter. Because the shadows on a person's face are small, they are difficult to measure directly with a "reflected" light meter of the type commonly built into through-the-lens metered cameras. "Incident" light meters measure the light falling on an object instead of being reflected off it, and so are easier to use for determining light ratios (see the *Appendix*). The difference between the incident reading taken with the meter pointed toward the sun and the reading taken with the meter pointed toward the reflector is the light ratio. (Care must be taken to make certain that light from one light source is not allowed to strike the meter when reading a different light source.)

However, it is possible to determine light ratios accurately with a reflected light meter. The procedure is to take consecutive readings off a surface such as a sheet of paper, first with the paper facing the sun, and then with the paper facing the reflector. Again, the difference in readings indicates the light ratio.

REFLECTORS

Any light-colored or shiny surface can be used as a reflector, but some are more convenient to use and produce better results than others. Sheets of white cardboard available from art supply stores work well (30″ × 40″ (16 × 102 cm) is a standard size, but larger and smaller sizes are also sold). A large sheet of cardboard which has been cut into sections and then rejoined by tape can be folded for easy carrying.

Photo supply stores sell reflectorized umbrellas, which have the advantage of being very portable. The umbrellas are sold with silver-, white-, and gold-colored reflective surfaces. Silver produces the brightest light, white the most even, and gold the "warmest."

Even a sheet of aluminum foil can make an effective expedient reflector. Wrinkling the foil before using it helps minimize the glare that smooth foil produces. In a pinch, even a sheet of newspaper can throw off enough light to be useful.

Positioning reflectors. Reflectors must be carefully positioned to throw light exactly where it is needed and with the necessary intensity. The reflector should be positioned so that its light compensates for the angle, elevation, and intensity of the sunlight. The more the light originates from one side of the subject, the farther to the other side of the subject the reflector is placed. The higher the sun in the sky, the closer to the ground the reflector is positioned. The brighter the sunlight, the larger the reflector or the closer it is to the subject.

Overcast days present both a problem and an opportunity. The problem is that very dark shadows appear on a subject's face. The opportunity is that with sufficient fill, the light on an overcast day can be made exceptionally smooth. The tech-

Light Ratios	
Ratio	Difference in f/stops
2:1	1
3:1	1⅔
4:1	2
5:1	2⅓
6:1	2⅔
8:1	3
16:1	4

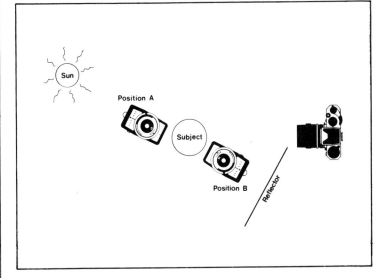

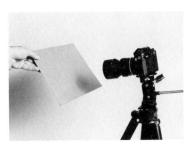

The intensity of the sunlight falling on a subject compared to the intensity of the reflected light thrown onto the subject is known as the light ratio. The light ratio can be determined either by pointing an *incident light meter* directly at the sun and then directly at the reflector (right), or by taking *reflected light* readings off of a sheet of cardboard, which is first held facing the sun and then held facing the reflector. Because the light ratio represents a comparison, the cardboard need not be a standard 18 percent gray so long as the same card is used for both readings.

nique involves placing reflectors well below the subject's face and aiming them toward the sky. Often the proper effect can be produced by having the subject hold the reflector in his or her lap.

Generally, in backlit photographs, the reflector or reflectors should be placed as close to the subject as possible without appearing within the photographic frame. Only in a portrait cropped tightly around the subject's face will the possibility exist of bringing the reflector in so close that too much light could be added.

POSITIONING THE SUBJECT OF AN OUTDOOR PORTRAIT

Outdoors the primary light source—the sun—is not directly under the photographer's control except to the extent that the direction the subject faces and where he or she is located affects the quality (hardness or softness) of the light illuminating the scene. Sunlight striking the subject's face directly will produce a different effect than light that has been reflected onto the face, or than light filtered through tree branches, or than the comparatively weak light that is present in a shaded area.

Each type of positioning presents its own problems. Direct sunlight falling on a subject's face can cause squinting. Reflected light can be so weak that depth of field becomes a problem. Light filtering through tree branches can create a mottled effect, which is very difficult to overcome. And photographing within an area of shade can also limit depth of field.

Backlight. A particularly advantageous orientation of subject, sun, and camera occurs in a "backlight": when the sun is located *behind* the subject. Especially with color film, backlit photographs usually produce outstanding portraits.

The key to making a successful backlit photograph is to add enough fill light to the front side of the subject to balance the intense light of the sun falling on the back of the subject's head. When the light ratios are correct, the subject's face is surrounded by an attractive highlight in which individual strands of hair are still discernible. If the background behind the subject is dark, the "halo" effect causes the subject to stand out distinctly and lends a three-dimensional feeling to the portrait.

Because in a backlight no direct light at all falls on the subject's face, reflectors must provide all frontal illumination. In order to generate enough light, reflectors need to be positioned

on both sides of the subject, often with a third reflector placed directly below the camera, just out of view. With color film, the fill light can be equally bright on all sides of the subject, but for black-and-white film the fill should be somewhat stronger in one direction to provide enough shading to give the face character.

Photographing in the shade. One method for avoiding the problems associated with direct sunlight is to move the subject into the shade. Near the dividing line between direct sunlight and the shade provided by a tree or building enough light spills into the shade to provide a sufficient amount of illumination to take a photograph. A subject standing in the shade but facing the sun is bathed in a smooth, flattering light. The nearer the subject approaches the rim of sunlight, the more flattering the light becomes. Usually, only a small amount of reflector fill is needed to provide a proper light ratio.

Positioning against a background. The background can serve either or both of two functions: to add a story-telling detail to a portrait, or to provide contrast between the subject and his or her surroundings. In general, the more clearly identifiable the background, the more pertinent it should be to the subject. The more extraneous or distracting the background, the more it should be obscured, either through selective focus or by virtue of the subject's position.

Regardless of the pertinence of the background to the subject, unless contrast is sufficient, the background is a detriment to the photograph. In general, a subject with dark hair should be positioned against a light background, and a subject with light hair against a dark background. Backlit subjects usually stand out best from a dark background.

YOUR PROJECT

Take some portraits outdoors of a person you know. Take some in direct sunlight, some in a backlight, and some in a shaded area. Take some photographs without using reflector fill, then repeat the photographs using fill. Be sure to take measurements with a light meter and record them on a sheet of

The photograph at left, above, illustrates many of the problems you might encounter when taking outdoor portraits. First, the sun is so bright that the boy is forced to contort his face in a squint. Second, the strong sunlight overhead has caused deep shadows to appear on his face and under his chin. Third, the background, which should be lending interest to the photograph, is distracting instead and too symmetrical. Finally, the photograph should be cropped more tightly around the boy's head and shoulders.
In the photograph right, above, moving in closer and having the boy place the hat on his head does not remedy the problems. The high contrast between the sunlit portions of his face and the shadow formed by the hat is too great for the film to retain shadow detail, so the boy's face assumes a grotesque appearance. And the fire truck, rather than supporting the portrait, dominates it.

paper. Pay attention to how moving reflectors affects light ratios. Try to develop an eye for how reflector fill affects shadows, and try to learn to estimate when light ratios are too wide for the film you are using. Use both black-and-white film and color—one or two rolls of each.

Evaluate your results in terms of how well the shading in your subject's face suits the portrait. In your backlit photographs, make sure that no direct sunlight is falling on the subject's face. Use the figures you recorded on paper to compare the appearance of a particular light ratio on black-and-white and color film. Note for future reference the ratio at which both the highlights and the shadows lose detail for each type film you used.

A SAMPLE PROJECT

In the sample results shown on these pages, some of the photographs illustrate faults commonly encountered in outdoor portraits. As you study the photographs, look for instances where high contrast produces shadows in which all detail is lost. Remember that in most cases the loss of detail is not apparent at the time the photograph is taken, but results from the inability of the film to respond to wide extremes of light intensity. Watch also for poor cropping, where the inclusion of extraneous elements distracts from a portrait.

The best solution to the problem of harsh sunlight in this sample project was to move into a shaded area and add a reflector. The photograph at right shows how the boy was positioned just inside the edge of the sunlight on a fender of the fire truck. Since he was leaning with his face sideways to the main light source, a white cardboard reflector was propped against a makeshift support to provide supplementary fill light.

The result, shown at left, is a becoming portrait of a young boy relaxing in an interesting and appropriate setting. The smooth light that was present immediately inside the shade of the garage casts a pleasing light on his face, and the fill light reveals shadow detail without eliminating the slight shading that defines the features of his face.

| # DISPLAYING A PRINT

Despite the personal pleasure a photographer may experience from the process of conceiving, taking, and contemplating his or her photographs, there is an additional measure of satisfaction to be derived from displaying photographs for the enjoyment of others. Certainly no photographer would want to display every photograph he or she has ever taken. However, the procedures for mounting and framing prints attractively are relatively so simple and inexpensive that every photographer owes it to himself or herself to select at least a few of his or her favorites and display them where they can be seen and appreciated.

WHAT YOU NEED TO KNOW

Preparing a print for display serves two functions: to hold a print securely, and to enhance the effect the print projects. A wide variety of methods are available for achieving both goals. Here, we have selected a few methods that strike an especially pleasing balance between simplicity and effect.

MOUNTING

Dry mounting. In dry mounting, you cut a sheet of mounting cardboard (available from framing shops and art supply stores) and then insert a sheet of dry mounting tissue (available in kits from photo supply stores) between the print and the board. When you apply heat, either from a special dry-mounting press or from a household iron, a permanent bond forms. Because of the heat involved, dry mounting is best used with fiber-based rather than resin-coated (RC) papers, which can easily be ruined by excessive heat.

Cold mounting. In cold mounting, instead of a heat-sensitive tissue, you sandwich a thin sheet of cardboard that has adhesive on both sides in between the mat and the print. Cold mounting works equally well for fiber-based and RC papers.

MATS

Once you have mounted a print, if you wish, you can surround it with an attractive mat border by cutting a "window" in a piece of mat cardboard (also available from art supply stores) and then laying the board on top of the mounted print.

The secret to making a perfect mat border is to bevel the edges of the window at a 45-degree angle as you cut them. An inexpensive yet effective device for cutting a beveled edge is the Dexter Mat Cutter. With this cutter, a metal straightedge, and a little practice, you will be able to cut professional-quality mat borders every time. Just be sure that the border overlaps the print by at least 1/8″ (3 mm) on all sides, has a width *at least*

For many photographers, a tastefully mounted and framed print represents the ideal culmination of the photographic process.

equal to one-quarter of the print's shorter dimension, and that you cut the underlying mounting cardboard large enough to accommodate the extra width added by the border.

FRAMES

Museums and art galleries almost invariably display photographs in simple, elegant silver or gold extruded-aluminum strip frames. These frames are reasonably priced and readily available from framing and art supply stores. Avoid the shoddily made, inexpensive versions commonly sold in five-and-dime stores.

Strip frames are sold as complete kits for use with standard size prints, or you can assemble frames in non-standard sizes by separately purchasing pairs of strips in the lengths you need and then having a sheet of glass cut to fit.

DISPLAYS

The method most commonly used to display photographs is to affix them, either singly or in groups, to a wall. As a minimum, you should mount the print on a mounting board, but a mat border and a frame are optional embellishments. Bear in mind, however, that prints exposed to air and light will tend to deteriorate, and that the frame and the mat border (which prevent the frame glass from contacting the print) serve not only to enhance the appearance of your prints, but also protect them.

If you are displaying a group of prints on the same wall, be careful to mount them in a consistent manner. Different framing methods or mat-border sizes present a disorganized appearance to the eye.

As a means of displaying a large number of your photographs over a period of time, you can continually replace the prints with new ones.

Another means of displaying your prints is to prepare a simple portfolio. Mount approximately fifteen prints on boards with mat borders and assemble the prints in an attractive leather portfolio case (available from art supply stores) with plastic pages, ready to be shown at any time.

YOUR PROJECT

Assemble the entire collection of photographs you have prepared in the course of executing these assignments and select at least one for display. Mount the frame on a mounting board, cut a mat border, and install the print in an aluminum strip frame.

A SAMPLE PROJECT

Dry-mounting and cold-mounting kits are produced by a variety of different manufacturers; the kits shown in this project are typical. Note that the dry-mounting kit indicates that it is designed for use with RC papers, but *only with a dry-mounting press.* You cannot control the temperature of a household iron with sufficient accuracy to dry mount RC papers, but you should have no difficulty mounting fiber-based papers with an iron.

Mat cutting with the Dexter Mat Cutter shown is relatively simple, although you should practice a few times to gain a feel

Cutting a mat border with a beveled edge is almost impossible to do freehand, but is a simple process with the right tool. The Dexter Mat Cutter shown here requires only that you mark out your cuts carefully and that you run the cutter along a firm straightedge. For the best results, use C-clamps to affix the straightedge securely to the tabletop and prevent any movement during the cutting. C-clamps are available from any hardware store.

Modern methods for mounting prints to mounting boards are easy to use and very reliable. At top, the protective layers on a sheet of cold-mounting paper are shown peeled back to expose the two adhesive layers. This sheet fits between the print and the mounting board. The roller, called a "brayer," is necessary to form a smooth, tight bond.

At bottom, a sheet of dry-mounting tissue is shown lying between a print and a sheet of mounting board. By the action of heat produced by either a mounting press or a hot iron, the adhesive contained in the mounting tissue bonds the print to the board.

A carefully mounted and framed print projects an image of excellence worthy of the amount of effort that a conscientious photographer invests in his work. It makes little sense to expend great effort on a photograph and then display it carelessly, if at all.

The way a photograph is displayed becomes part of the photograph itself.

The mat border in the above photograph is unusually large and greatly affects the impression this photograph makes. Imagine how different this photograph would look had the mat border not been added.

As long as a mat's borders are not narrower than approximately one-quarter of the width of the shorter dimension of a print, any border shape can be acceptable. In the photograph opposite, the border is approximately one half the width of the shorter print dimension. Above, the border sizes are even more extreme and the print is not even centered within the mat.

The decision as to the border shape is entirely up to you and your sense of what looks good.

for using the instrument. You can use the same type of cardboard for making the border that you used to mount the print. Be sure to plan your cuts carefully in advance, of course, and do not skimp on the border. A print will look far better with too much border than not enough. Save the "window" cardboard for later use in mounting a smaller print.

Notice how simple but attractive the aluminum frames look. In a quality frame, the junctions of the four strips fit together smoothly. In cheap frames, gaps exist which detract from the appearance of the entire photograph.

In making decisions as to which brands of materials to buy, remember that if you want others to view your work with respect, you must yourself treat it with respect. Inferior materials and sloppy workmanship project an image of carelessness that will significantly influence the regard in which others hold your work.

This photograph was shot on a light table in a manner similar to that used for photographing the paper in Project 1. Kodak Recording Film was used to enhance grain. The "horizon" was intentionally located so that it bisected the egg symmetrically as a counterpoint to the egg's slight asymmetry.

25 | APPLYING WHAT YOU HAVE LEARNED

YOUR FINAL PROJECT

Drawing upon all of the knowledge you have gained from the previous projects, produce five interesting photographs of an egg. Use as many of the techniques that you have learned as you can, and try to exercise your mind and your skills to the limit. Do not be satisfied until you are certain that you have produced the very best photographs of which you are capable. Do not copy the results shown here, but come up with your own ideas.

Compare your results with those you obtained when you photographed the paper in Project 1. Are they similar? Do you see improvement? How would you photograph the paper now? Do it.

If you have learned nothing else in the course of completing the projects in this book, it should be that the effect and quality of a photograph lies not within a particular subject, but within *you.* Your ability to see light, and to see an object in terms of how it reacts to light and will appear on film is the essence of photography.

This is not to minimize the importance of technique. The ability to visualize a photograph is of little value unless you can transfer your vision onto film. Without having exercised the self-discipline involved in developing technical skill, your knowledge is at best superficial. Part of the reward for having spent long hours completing these projects is an increase in technical skill.

Beyond technical skill, however, is skill in application. There is only one way to learn to be a photographer, and that is to *do* photography. Skill in application is an acquired ability.

The next time you feel the urge to create, pick up your camera and *do* it. Photographs are all around you, waiting for you to notice them and commit them to film. Each time you make the effort, your ability to apply your skills will become further developed, your eye will become sharper, and your senses will become keener.

Photography finally boils down to nothing more than the ability to manipulate light and skill and imagination. Practice until you become a master at using light to serve your creative ends.

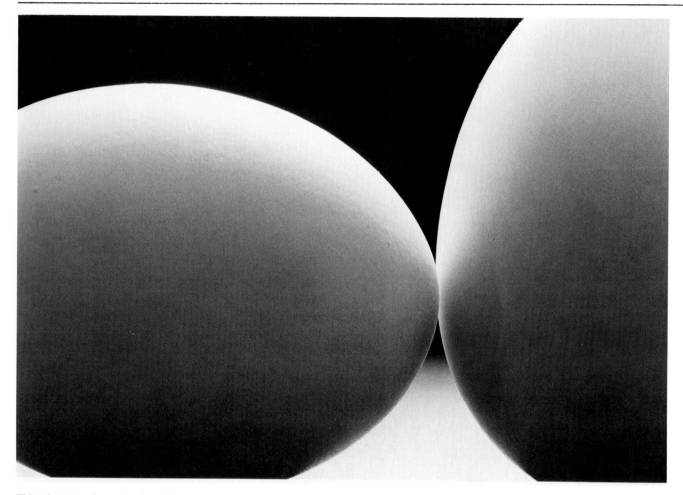

This photograph emphasizes the abstract elements of the eggs' form. The scene was illuminated by a backlight, with just enough fill light added to reveal some of the eggs' surface texture. Care was taken to orient light areas of the eggs against dark areas of the background and dark areas of the eggs against light areas of the background.

APPENDIX

The most common type of light meter used by photographers measures the amount of light being reflected off of an object and into the camera. These meters are calibrated to yield an exposure that is a neutral gray tone. Most through-the-lens light meters provide these reflected readings.

The problem with reflected readings is that they do not depend on the amount of light falling on a scene, but the amount being reflected from an object. Since different objects reflect varying amounts of light, depending on the object's tone and on where the reading is being taken (highlight, shadow, or in between), reflected light readings can vary over a broad range. In addition, whenever the area of a scene being used to take the reading is not on average equal to an 18 percent gray tone, the meter will indicate exposure settings which will render the area, from which the reading was taken, gray in the final print.

Incident light readings work on a different principle. An incident reading is a measurement of the amount of light entering a scene, rather than the amount leaving it through reflection. As a result, incident readings tend to be more accurate than reflected readings, although often the differences are inconsequential. However, in some situations—when a correct exposure of a person's face is needed, for example—incident readings are essential.

The easiest way to take an incident light reading is with a hand-held meter equipped with an incident light dome. (On some meters the dome remains permanently over the sensor. On other meters, the dome can be pushed aside when reflected readings are needed.) To take the incident reading, the sensor is held near the subject of the photograph and pointed *at the light source.* If more than one light is illuminating the scene, the reading is best taken by pointing the meter at the camera.

A reflected light meter can be used to measure the equivalent of incident light if the reflected readings are taken off an 18 percent gray card (readily available in camera stores). The technique is to place the gray card within the scene and take the reflected readings off of the card using either a hand-held meter or a meter built into a camera. This procedure will yield readings that are identical to the incident reading.

When the goal is to determine light reading *differences,* care must be taken to make certain that only light from a single source strikes the cardboard at one time. Similarly, it is important that none of the light is blocked by the meter, camera, or person taking the reading.

Abstract—Removed from concrete reality; emphasizing lines, geometric shapes and forms, and colors.

Acrylic plastic—Sheets of hard plastic used in photography as surfaces on which objects are placed. Plexiglas is a brand of acrylic plastic.

Aperture—The adjustable opening of a lens diaphragm through which light passes.

ASA—A film speed rating convention, established by the American Standards Association, applied to a film to characterize the film's sensitivity to light. (See also *ISO*)

ASA/ISO—(See *ASA; ISO*)

Available light—The light—either natural or artificial—already present in a scene when the photographer arrives. The term usually implies that the light is weak.

Backlight—Light originating from behind the subject of a photograph. Anytime the angle formed by the camera, the subject, and the light source is greater than 90 degrees, backlight will be present.

Balance—(See *color balance*)

Blur motion—The blurring of an image on film due to the perceptible movement of the image while the camera shutter is open. (Also referred to as motion blur)

Bracketing—Traditionally, a series of photographs of the same scene that differ from one another only in exposure. Brackets are usually made at one *f*-stop on either side of the exposure called for by a light meter. In photographing moving objects, the term can imply taking identical exposures at different shutter speeds in order to obtain a range of blur motion effects. (See *blur motion*)

"Bulb" setting—The "B" shutter speed setting present on most cameras used to keep the shutter open for as long as the shutter-release button remains depressed.

Cable release—A mechanical device which permits a camera's shutter to be released without inducing camera shake. Usually, thumb pressure applied to one end of the cable is transmitted to the shutter-release button.

Camera shake—Movement of the camera, usually due to its being handheld or due to the effect of pressing the shutter-release button without using a cable release. With a normal lens, camera shake is usually a problem only at shutter speeds slower than 1/250 sec.

Changing bag—A light-tight cloth bag within which light-sensitive materials (unprocessed film or printing paper) can be handled while room lights are on or sunlight is present.

Cold colors—Muted tones including the greens and blues.

Color balance—The relationship between colors in a print. When color balance is correct, the colors in a print closely or exactly reproduce the colors in the original scene. Color balance is affected by the colors contained in the light source used to produce or view an image.

Color temperature—A way of describing the color produced by a light source and measured in degrees Kelvin. Each type of color film responds most accurately to light of a particular color temperature.

Composition—The arrangement of the parts of a photograph to achieve a unified and aesthetically pleasing design.

Compositional frame—Objects incorporated into a photograph that surround the main subject and direct attention to it. (See *strong frame; weak frame*)

Contrast—The range of light intensities contained in a scene or a photographic image. Scenes or images showing little difference in intensity between the darkest tone and the lightest tone are said to be "low contrast." Scenes or images showing a great difference in intensity between the darkest tone and the lightest tone are said to be "high contrast" or "contrasty".

Contrast grade—A designation of the range of light intensities a particular sheet of printing paper will produce. The commonly encountered grades run from 1 (low contrast) to 5 (high contrast).

Contrasty—(See *contrast*)

Daylight film—Film balanced for use in the presence of sunlight or with electronic flash.

Depth of field—The range of distances in front of a lens that will be rendered in sharp focus by the lens. The depth of field generated in a particular situation depends on focal length of the lens (the longer the focal length, the shallower the depth of field), the lens aperture selected (the wider the *f*-stop, the shallower the depth of field), and the point at which the lens is focused (the nearer the point, the shallower the depth of field).

Diaphragm—A mechanical device built into photographic lenses that permits the size of the lens aperture to be adjusted and thereby controls the amount of light that reaches the film. Rotating a ring on the outside of the lens causes the diaphragm to change to a different aperture (*f*-stop). (See *aperture*).

Diffusion filter—An optical device mounted on a lens designed to scatter light and soften the definition of an image.

Electronic flash—A bright artificial light of short duration produced by an electronic process whereby stored electricity activates special gasses. The light produced approximates the color of daylight. Also called a strobe.

Exposure—The particular combinations of lens aperture (*f*-stop) and shutter speed that will allow the proper amount of light to strike film or printing paper to record the best possible image. (See *aperture*)

Exposure latitude—The range of exposures, including overexposures and underexposures, that produce at least some detail in the highlights and shadow areas of an image. The exposure latitude of black-and-white film is approximately five stops, of color film approximately three stops.

Exposure value—The brightness of an object. Once an object's exposure value is determined, the combinations of lens aperture and shutter speed that will result in a proper exposure are easily determined.

F-stop—1. A numerical description of the size of a lens aperture. The specific number represents the ratio between the lens focal length and the diameter of the opening. 2. A way of describing differences in the intensity of light, as when one light intensity is said to differ from another by a certain number of *f*-stops.

Fast film—Film which is relatively very sensitive to light. Films rated above ASA/ISO 320 are generally considered to be "fast."

Fill light—Supplementary light reflected onto an object or into a scene to reveal detail in shadowed areas.

Film plane—The surface in a camera on which a focused lens forms a sharp image.

Filter—A clear or translucent piece of glass, gelatin, or acetate that is placed between a source of light and a piece of light-sensitive material to alter the light in some predetermined fashion. Some filters affect color, others are designed to absorb unwanted radiation, and still others modify the way an image appears (e.g. diffusion filters).

Filter factor—A number that specifies the amount of adjustment (increase in exposure) necessary when using a particular filter.

Fine-grained film—Film in which the structure of silver clusters in the emulsion layer is comparatively small after development. (See *grain*)

Flare—(Sometimes referred to as "lens flare.") Polygons of light or a general haze that occurs when direct light enters a lens and reaches film.

Flat light—Low-contrast light, i.e., light that produces very little difference in brightness between light and dark areas. The larger the surface of a light source, the flatter the light it produces. Contrasty light can be flattened (softened) through the use of reflectors. (See *contrast*)

Focal length—In most lenses, the distance from the optical center of a lens to the point behind the lens where a sharp image forms, when the lens is focused on infinity. A lens's focal length affects the angle of view and the size of the image produced.

GLOSSARY

Gobo—Any device used to block light.

Grain—Clumps of metallic silver that are always formed on film and prints. With fine-grained film, the grain is barely noticeable to the naked eye. With grainy film, the clumps are readily apparent. Film grain increases with film speed.

Gray card—A sheet of cardboard carefully dyed to produce an 18 percent middle-gray tone.

Hard light—Light that simultaneously produces bright highlights and dark shadows with distinct lines of demarcation. (See *contrast*)

Highlights—The brightest portions of a scene or image.

Hyperfocal distance—The distance in front of a lens at which the lens can be focused to provide the most extensive depth of field possible with that lens, at that *f*-stop.

Incident light—The light falling on an object, as opposed to the light reflected by the object.

Incident light meter—A light meter designed to measure the intensity of the light falling on a scene or subject. The light sensor on an incident light meter is covered by a translucent dome which causes the sensor to receive an "average" of all the light striking a scene.

Intensity—In photography, brightness of light.

ISO—A film speed rating convention established by the International Standards Organization which combines ASA and DIN ratings into a single film speed designation. For example, film which was formerly rated as ASA 64/19 DIN is now rated ISO 64/19°.

Kelvin degrees—A unit of measurement of color temperature that corresponds to wavelengths of light.

Lens flare—(See *flare*)

Light ratio—The comparative difference in brightness between two objects.

Light table—A surface made of translucent material (usually acrylic plastic) through which light can be passed from below.

Mask—An opaque object, usually a sheet of black cardboard, used to block part of an image from reaching the film.

Mat—A cardboard frame that lies over a print to secure it in place and to form a border around the print.

Mismatch—The use of light of a color temperature other than the one for which the film being used is *balanced*. Mismatching results in inaccurate color rendition.

Modelling effect—Gradations in tone which help to reveal the shape of an object. Objects illuminated directly from the front show little or no modelling. As the light moves more and more to the side, the modelling

effect increases. *Flat light* produces little or no modelling.

Multiple exposure—Exposing the same frame of film two or more times.

Mylar—The brand name of a thin, highly reflective plastic material sold in sheets or rolls. Mylar is useful as a background in photography because it forms a single reflective image, unlike a mirror, which at some angles of view forms a double image (one image from the silvered surface, and one image from the glass surface).

Opaque—Passing no light.

Overexposure—To allow more light to strike film than the optimal amount required for the best possible image.

Panning—Following the motion of a moving object with a camera so that the object does not appear blurred in the photograph.

Portfolio—1. A portable case for carrying loose prints. 2. A collection of photographs that represent a photographer's work.

Push processing—A procedure whereby film that has been shot at an ASA/ISO higher than that assigned by the manufacturer is developed for a longer time than normal or processed using special chemicals.

Pushing—Intentionally underexposing film by shooting as if it had an ASA/ISO rating higher than that assigned by the manufacturer. Pushed film must be accompanied by *push processing.*

Quartz lights—High intensity lights used in photography that are characterized by a consistent color temperature throughout the life of the lamp.

Reciprocity effect—A characteristic of film whereby a correct exposure occurs at a variety of easily predictable combinations of lens aperture and exposure time. At very long or very short exposures, the relationship between lens aperture and shutter speed becomes erratic, a situation referred to as *reciprocity failure.*

Reciprocity failure—(See *reciprocity effect*)

Reflected light—Light that has struck an object and then been cast off. The wavelengths of light reflected are determined by the nature of the object.

Reflected light meter—A light meter that measures the amount of light being cast off by an object or scene and then indicates exposure settings that will render that object or scene in an average 18 percent gray tone.

Rimlight—A bright halo of light surrounding an object produced when bright, direct light falls on the object from behind at the same time that indirect, reflected light falls on the object from the front.

Seamless paper—Wide sheets or rolls of paper used to give the illusion that objects placed upon the paper are "floating" in undefined space.

Selective focus—A technique whereby depth of field is used to render some objects in sharp focus while other objects appear blurred.

Self-timer—A device built into many cameras that permits a delay between when the shutter-release button is depressed and when the shutter actually opens.

Slow film—Film with an ASA/ISO rating below 50.

Smooth light—Light that does not produce shadows. Surrounding an object with large reflectors will produce a smooth light.

Soft light—Light that produces a relatively narrow difference between highlights and shadows. The shadows formed by a soft light do not have sharp edges. (See *hard light*)

Strobe—(See *electronic flash*)

Stroboscopic effect—The effect of making multiple exposures of a moving object through rapidly repeated flashes from a strobe.

Strong frame—A compositional frame that directs attention to a photograph's main subject without dominating or detracting from the subject.

Tent—A cone of translucent material placed around a small object. Lights directed onto the surface of the tent from outside illuminate the object with a smooth light.

Tone—A shade of gray or of a color.

Translucent—Permitting light to pass but diffusing it in the process.

Tungsten film—Film designed for use with tungsten-filament lamps. Tungsten film used in daylight or with electronic flash acquires a blue cast.

Umbrella—A white device, similar in appearance to a rain umbrella, used to soften light by reflecting or diffusing it.

Underexpose—To allow less light to reach film than the optimal amount required to form the best possible image.

Velveteen—A synthetic material similar to velvet. In photography, velveteen is used any time a "dead" black background is wanted. Black paper produces reflections that can be detected in a photograph.

Warm colors—Reds, oranges, and yellows.

Washed out—The state of being so overexposed that all detail is lost.

Weak frame—A compositional frame that distracts attention away from the main subject of a photograph.

INDEX

Abstract composition
 applications project, 159
 shadow photography, 138
 subject investigation, 127
Abstract composition, project, 130-135
Accessories
 basic needs, 11
 See also Camera; Lenses; Light meters
Applications project, 157-161
Architectural form, 23
Architectural photography
 compositional framing, 65
 See also Travel photography
ASA numbers, 53, 56
Available light, 59
Available light, project, 34-39

Background
 outdoor portraits, 146
 portrait photography, 60-61
 translucent subjects, 89
Background project (seamless), 76-81
Backlight and backlighting
 outdoor portraits, 145-146
 texture and form, 23
Backlighting project (single), 82-87
Black-and-white film and photography
 contrast, 109
 film properties, 53
 filters for, 11, 47
Blur. *See* Motion photography, project
Bracketing
 shutter speed, 73
 sun photography, 113
 sunset photography, 121-122
Bulb setting, 100
Bulk film loaders, 10

Cable release, 31
Camera(s)
 basic needs, 11-12
 reflective photography and, 95, 97
 See also Accessories; Lenses; Light meters
Camera format, 53
 subject investigation, 125-126
Camera shake, 31
 See also Tripods
Cardboard reflectors
 basic needs, 11
 reflective subjects, 95
 See also Reflectors
Cityscapes, 30-33
Cold mounting, 151
Color balance, 53
Color film and photography
 film properties, 53
 filters for, 11, 47
 prepaid film, 10-11
 sunsets, 119, 121
Color shift, 50
Composition
 backlighting, 83-85
 shadow photography, 139

Compositional framing, project, 64-69
Contrast
 available light photography, 35-36
 scenic photography, 108, 109
 shadow photography, 139
Cropping, 139

Darkroom processing, 10
 contrast control in, 109
Depth of field, 105-106
Display project, 150-155
Double exposure, project, 98-103
Dry mounting, 151

Egg photography, project, 157-161
Enlargement, 51
Equipment. *See* Accessories; Camera(s); Lenses; Light meters
Exposure
 available light, 35-36
 light, 16-17
 night photography, 31-33
 See also Bracketing
Exposure latitude, 35-36
Exposure meters. *See* Light meters
Eye movement, 65

Film
 double-exposure photography, 100
 portrait photography, 59
 scenic photography, 105
Film loaders (bulk), 10
Film properties, project, 50-57
Filters
 basic needs, 11
 sunset photography, 119, 121
 travel photography, 47
Flash units
 basic needs, 11
 portrait photography, 59-60
Flood lamps
 backlight photography, 83-85
 basic needs, 11
Focal length, 72
Form. See Texture and form
Frames, 152
Framing. *See* Compositional framing

Glassware. *See* Translucent subjects
Gobos, 79
Grain
 enlargement and, 51
 film and, 51

Hard light, 41
Hyperfocal distance, 106, 109

Incident light meter, 16, 163
 See also Light meter
Infinity, 106, 109

Journalistic portrait photography, project, 58-63

Lens distortion, 60
Lenses
 basic needs, 11-12
 double-exposure photography, 99-100
 portrait photography, 59, 60-61
 scenic photography, 105-106, 109
 See also Accessories; Camera(s)
Lens flare
 backlighting, 85
 sun photography, 115
Light and light sources
 abstract composition, 131, 135
 applications project, 160
 backgrounds, 79
 backlighting, 83-85
 basic needs, 11
 color balance, 53
 exposure and, 16-17
 night photography, 31
 outdoor portraits, 143-144, 145-146
 portrait photography, 59-60
 reflective subjects, 95
 scenic photography, 107
 subject investigation, 129
 sun, 112-117
 texture and form, 21-23
Light meters, 162-163
 available light photography, 36
 backlighting, 85
 light table, 29
 night photography, 31
 outdoor portraits, 143, 144
 reading of, 16-17
 scenic photography, 109
 sun photography, 113
 sunset photography, 121-122
 translucent subjects, 90
 window photography, 43
Light projects, 15-19
 available light, 34-39
 light table, 26-29
 window light, 40-43
Line, 17

Mats, 151-152
Metering. *See* Light meter
Motion, 106
Motion photography project, 70-75
Mounting, 151

Nature. *See* Scenic photography
Night photography, 30-33

Outdoor portraits, project, 142-149

Panning, 72
Portrait photography (outdoor) project, 142-149
 See also Journalistic portrait photography, project

Prepaid color film, 10-11
Print display, project, 150-155
Processing. *See* Darkroom
Pushing film, 53, 56

Reciprocity and reciprocity failure, 31, 33
Record keeping, 12
Reflections
 abstract composition, 132
 reflective subjects, 93, 95
 translucent subjects, 89
Reflective subjects photography, project, 92-97
Reflectors
 available light photography, 37-38
 backlighting, 83-85
 basic needs, 11
 outdoor portrait photography, 144-145
 portrait photography, 60
 reflective subjects, 95
 seamless backgrounds, 79
 window light, 41-42

Scenic photography, project, 104-111
 See also Travel photography, project
Seamless backgrounds, project, 76-81
Shade, 146
Shadow photography, project, 136-141
Shutter speed, 71-72, 73
Single backlighting, project, 82-87
Soft light, 41
Subject investigation, project, 125-129
Subject position, 145-146
Sun photography, project, 112-117
Sunset photography, project, 118-123
Surface texture, 23

Telephoto lenses, 122
Texture and form, project, 20-25
Translucent subjects, project, 88-91
Travel photography, project, 88-91
 See also Scenic photography, project
Tripod
 basic needs, 11
 night photography, 31
 portrait photography, 60
 scenic photography, 106

Umbrella reflector
 basic needs, 11
 portrait photography, 60, 61
 seamless backgrounds, 79
 See also Reflectors

Wide-angle lens, 60
Window light, 160
 project for, 40-43